IMAGES
of America

VANISHING
SEATTLE

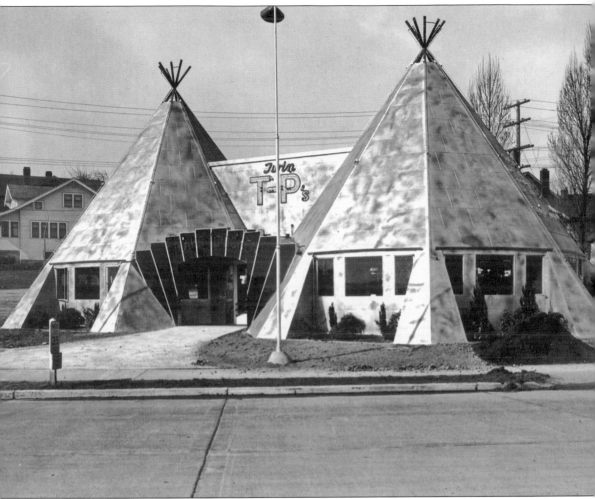

The Twin Teepees restaurant (also known over the years as Clark's Twin T-P's and Power's Pancake House) opened in 1937 on Aurora Avenue. Delland Harris's design featured a bar and kitchen in the northern cone and a dining room with an open-pit fireplace in the southern cone. Harlan Sanders once worked in the kitchen while perfecting his fried-chicken recipe. A kitchen fire closed the place in 2000; its landlord demolished it without notice a year later. The site remains vacant today. (MOHAI, *Seattle Post-Intelligencer* collection, No. 1986.5.11405.)

ON THE COVER: The Aurora Avenue "world headquarters" of Dag's Drive-Ins served "Beefy Boy" and "Dagilac" burgers from 1955 to 1993. Founders Boe and Ed Messett named the chain after their father. The brothers had previously sold cemetery monuments at the Aurora site. Eight other Dag's opened over the years, and the chain was noted for its inventive promotions and slogans (mostly by press agent Bob Ward). One slogan referred to a nearby upscale steakhouse: "This is Dag's . . . Canlis is ten bucks north." (Museum of History and Industry [MOHAI], No. 2004.57.)

IMAGES
of America

VANISHING
SEATTLE

Clark Humphrey

ARCADIA
PUBLISHING

Published by Arcadia Publishing
Charleston SC, Chicago IL, Portsmouth NH, San Francisco CA

Printed in the United States of America

Library of Congress Catalog Card Number: 2006931269

For all general information contact Arcadia Publishing at:
Telephone 843-853-2070
Fax 843-853-0044
E-mail sales@arcadiapublishing.com
For customer service and orders:
Toll-Free 1-888-313-2665

Visit us on the Internet at www.arcadiapublishing.com

To everyone who still remembers the past and still believes in the future.

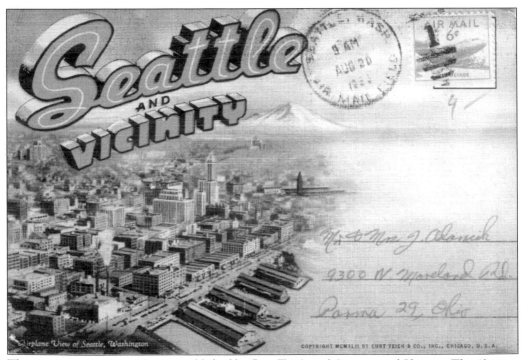

This 1940s postcard booklet was published by Curt Teich and Company of Chicago. The 42-story Smith Tower (beneath the "t" in "Vicinity") was the tallest building in the western United States when it was built in 1914. It remained Seattle's tallest until 1968. (Author's collection.)

CONTENTS

ACKNOWLEDGMENTS

No project this broad in scope could rely on just a few sources. Countless people in many places helped locate the images used in this book:

- University of Washington Special Collections, particularly Nicolette Bromberg.

- The Seattle Public Library Seattle Room, particularly Jodee Fenton.

- The Museum of History and Industry, particularly Carolyn Marr.

- The Seattle Municipal Archives, particularly Jeff Ware.

- Pacific Publishing Company, particularly Mike Dillon.

- The Shoreline Historical Museum, particularly Vicki Stiles.

- The Hydroplane and Raceboat Museum, particularly David Williams.

- HistoryLink, particularly Walt and Marie Crowley.

- The private hunters and gatherers, in no particular order: Deran Ludd, Charlotte Buchanan, Jean Flynn, Lori Lynn Mason, Megan Lee, Dave Eskenazi, S. J. Pickens, Eileen Massucco, Tom Blackwell, Louie Raffloer, Steve Callihan, Charles Peterson, Cam Garrett, Chris Wedes (J. P. Patches himself), Pete Kuhns, Joel Van Etta, Chuck Taylor at *Seattle Weekly*, Mimi Payne, Kerrick Mainrender, Willum Hopfrog Pugmire, Jeff and Rochelle Mecca, Michael Shafae, Elaine Bonow, Brittany Wright, Art Chantry, Michael Fairley of Fairlook Antiques, Sarah and Angel of Jules Maes Saloon, and everyone who helped look or who knew someone who knew someone who might have something.

Editor Julie Albright provided a few special keepsakes from her own memorabilia, in addition to shepherding the whole project.

Special thanks go out to the photographers who observed and captured everyday life in the city, including Mary Randlett, Leslie H. Hamilton, Werner Lenggenhager, Clifford B. Ellis, and Art Hupy.

Barbara Krohn first introduced me to the cause of historic preservation in 1978. She's still at it today.

INTRODUCTION

Chief Sealth, for whom the city of Seattle is named, allegedly said in 1854, "These shores shall swarm with the invisible dead of my tribe, and when your children's children shall think themselves alone in the field, the store, the shop, upon the highway or in the silence of the woods they will not be alone . . . At night, when the streets of your cities and villages shall be silent, and you think them deserted, they will throng with the returning hosts that once filled and still love this beautiful land."

Another wise sage, comedian John Keister, said in 2000, "A city loses its soul one building at a time. Every neighborhood had its own unique gas station or retail core, like that row of businesses north of Green Lake that was knocked down for another condo with a bagel shop. Longacres, Abruzzi's Pizza; they go one by one until you say, 'Where did the city go?' It's pretty much gone."

Northwest America's premier city is only 155 years old. But what little history it has accumulated gets tossed aside too often in favor of something newer, bigger, more opulent.

This place has gone through so many changes, ever since the first white settlers came and the original residents were moved out. The trees of First Hill were cut and skidded down Yesler Way, on the original "skid road." The great Seattle fire of 1889 destroyed most of the original pioneer settlement; a new downtown of bricks and steel arose in its place. Entire hills were sluiced and bulldozed during the Denny Regrade, and the dirt was used to fill in tide flats and build Harbor Island. Prohibition came and went. The Japanese-American community was forced into relocation camps during World War II. Boeing aircraft became Seattle's chief export product. The economy repeatedly boomed and busted. Suburban sprawl hit the outlying areas and took many working-class families away from the city. Advocates for race and gender equality demanded to be heard. High-rise office towers arose, followed by high-rise condominiums. Major league sports teams showed up. A growing professional class patronized "foodie" restaurants and chic boutiques. Software companies and dot-coms rose and, in some cases, fell. Postmodern "showpiece" architecture replaced efficient modern architecture. Dale Chihuly's glass bowls became Seattle's most recognized art exports, succeeding the modernistic mysticism of Mark Tobey and Morris Graves. Real estate hyperinflation helped obliterate the remaining vestiges of the city's more downscale past.

This book mostly depicts aspects of Seattle's public life that (1) were prominent during the second half of the 20th century and (2) aren't here anymore, at least not in the ways they used to be. Some of your personal favorites might not be here; that's just the nature of such a project as this.

These aren't just memories. They aren't even just fond baby-boomer memories. These are ghosts, apparitions of the city that was, America's own shining City on Seven Hills, a place of informality yet of taste and class, of hard work combined with hope for a brighter future.

This is a scrapbook of dreams that were lost but could return if we really wanted them.

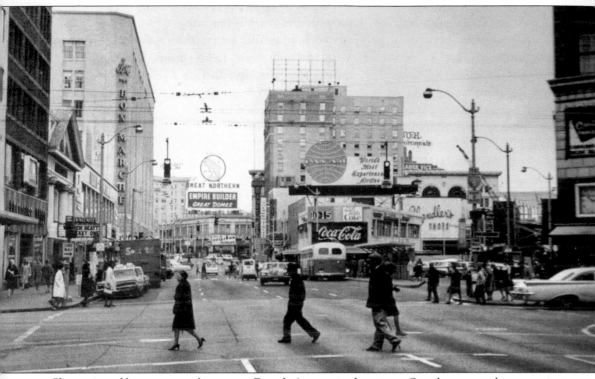

Shoppers and business people traverse Fourth Avenue in downtown Seattle on a random morning in 1968. The view includes the Bon Marché, Bartell Drugs, a Societé candy truck, the Ben Paris restaurant, the Colonial Theater, a Manning's coffee shop, and neon billboards for the Great Northern railway and Pan Am airlines. (Mary Randlett collection.)

One

STORES

Our own remembrance of lost time starts not with a cookie but with a shopping bag. The marketplace is the classic urban gathering place. Seattle's marketplaces have changed constantly, whether to meet changing consumer demands or to accommodate corporate consolidations.

In 1964, there were six department stores downtown, none of which was Nordstrom. Today there are two department stores downtown, of which Nordstrom is the surviving grand old lady.

Two dozen old mom-and-pop grocery stores could fit into each of today's largest QFC or Larry's supermarkets. Corner drugstores and hardware stores gave way to big-box behemoths. Even bookstores became huge.

Recreational Equipment Inc., founded as a means for serious sportsmen to obtain serious mountaineering tools, is now a deluxe outdoor-recreation superstore complete with its own climbing wall and mountain-bike track.

Delightful kitsch-decor boutiques and antique shops have fallen to high rents. Dingy, sleazy "adult novelty" stores have given way to female-friendly "lovers' toy" stores.

Even the Pike Place Market, administered under the official control of a Preservation and Development Authority, has changed. Originally devised to cut prices by bringing farmers and shoppers together, it's now advertised as a tourist attraction and a gourmet's paradise.

Some big name operations have come to town and left again, such as FAO Schwarz. Others, like Wal-Mart and Ikea furniture, influence Seattle's retail economy from suburban outposts without setting foot inside the city limits.

And established commercial pillars, admired by all and seemingly destined to live forever, have shriveled and died off, including Littler, John Doyle Bishop, and the store where our journey begins.

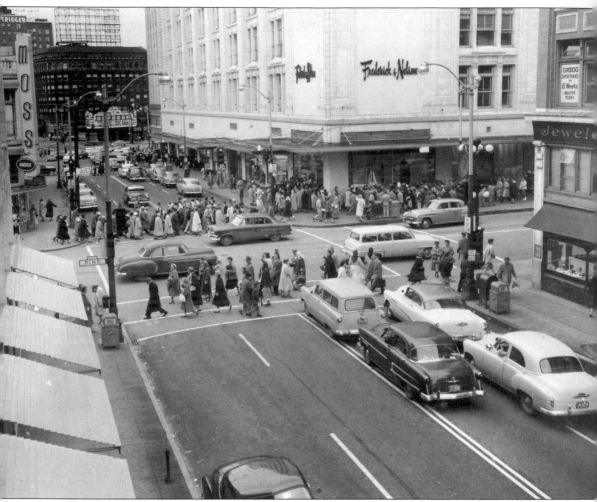

Donald E. Frederick and Nels Nelson started a used furniture store on Second Avenue in 1890. It initially thrived in helping families furnish their postfire homes. Over the next quarter century, the store expanded into apparel, shoes, and food. Frederick, who took over after Nelson's 1907 death, built the business on quality merchandise, understated good taste, and impeccable customer service. In 1918, Frederick undertook a bold move away from Second Avenue, then Seattle's premier shopping street. He built a steel and terra-cotta shopping palace at Fifth Avenue and Pine Street, initially dubbed "Frederick's Folly" by local wags who thought it a dumb idea. Instead, Frederick thrived at the new store, which became the anchor for Seattle's new principal retail district. It is seen here following a 1951 expansion, which added five more floors. The new store had three restaurants—an elegant tea room, the distinguished Men's Grill (for husbands who sought a respite from chattering females), and the Paul Bunyan Room (a coffee shop and soda fountain in the bargain basement). (MOHAI, *Post-Intelligencer* collection, No. PI-23265.)

The store's in-house display department prepared colorful window treatments throughout the year but saved its most elaborate statements for Christmas. F&N also had one of the first department store Santas. Donald Frederick retired in 1929 and sold the store to Chicago's Marshall Field and Company, who kept the store's management and traditions in place, but F&N's post–World War II expansion was throttled by Field's tight purse strings. Chicago management approved the downtown expansion and three relatively small suburban stores but refused to participate in Northgate, the region's (and the nation's) first major shopping mall. By the 1970s, a fast-growing Nordstrom had eclipsed F&N as the Northwest's dominant high-fashion retailer. (Both Julie Albright collection.)

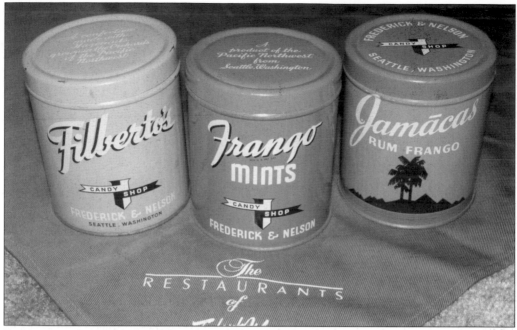

Frango mints and related candy products were the signature products of Frederick and Nelson's food kitchens. Marshall Field's took Frangos to Chicago after buying F&N; when the two chains were divorced in the 1980s, Field's kept the trademark. (Artifact, Julie Albright collection; photograph, author collection.)

Here is a 1980s F&N advertisement from the store's desperate, declining years. British-American Tobacco bought Field's, imposing out-of-character "hip" and cheap styles on Frederick's. BAT then unloaded F&N onto local developer Basil Vyzis, who then sold it to another local developer, David Sabey. By then, creditors were circling, shoppers were sparse, and racks were bereft of what anyone wanted to buy. The store's grand traditions ended in May 1992. (Ann Wendell.)

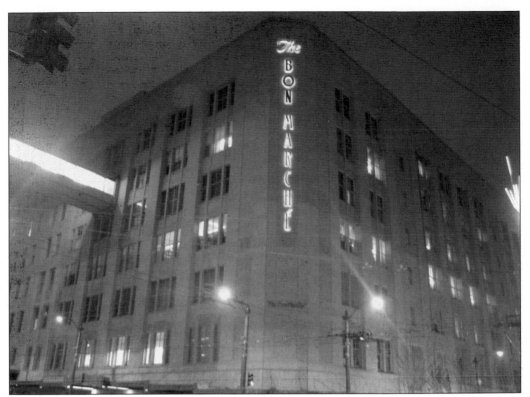

Josephine and Edward Nordhoff arrived in Seattle in 1890 and spent $1,200 to open a small general store. Because space was scarce after the great fire, they set up shop in William Bell's Belltown district, more than a mile from the city's heart in Pioneer Square. Within eight years, their store, the Bon Marché (named after the Nordhoffs' favorite Paris store) joined Seattle's other department stores on Second Avenue. It bought and built adjacent buildings until it filled a half block. In 1910, it claimed to be "the largest department store on the Pacific coast." In 1929, the Bon followed F&N to Pine Street, building a full-block structure between Third and Fourth Avenues. Before the new store opened, it was bought by Hahn Department Stores (later Allied Stores). (Above, author's collection.)

The Bon Marché
SEATTLE

After World War II, the Bon (the store's informal name, and its official name from 1975 to 1989) grew quickly. It first bought up smaller stores throughout the state. Then in 1950, Allied built (and the Bon anchored) Northgate. The downtown Bon added four floors and a skybridge-connected parking garage. In the 1960s, Allied built Tacoma Mall and Southcenter; other suburban Bon branches arrived in the 1970s and 1980s. But no amount of local goodwill or local market share could save the Bon's local identity from Federated Department Stores, which bought Allied and several other chains. Federated placed all its nationwide acquisitions (except Bloomingdale's) under the Macy's brand. (Seattle Public Library Seattle Room.)

After the Bon moved to Fourth Avenue, J. C. Penney took its former Second Avenue and Pike Street site, a half block from the Pike Place Market. It was open from 1930 to 1982; during most of these years, it was the national chain's biggest store. Mr. Penney himself often visited, accompanied by his old friend, Seattle banker-industrialist Joshua Green. The building was razed in 1991 for the Newmark condominium tower. (Seattle Municipal Archives.)

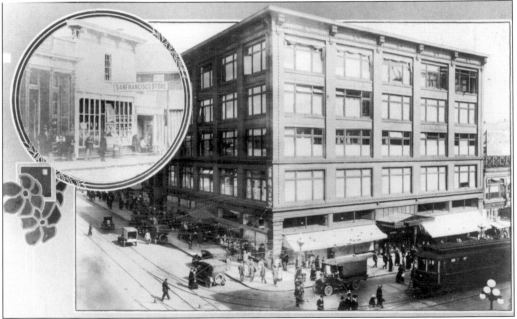

MacDougall-Southwick was descended from the San Francisco Store, a pioneer dry-goods outlet opened in 1875. By the time of this 1916 shot, it was at Second Avenue and Pike Street (across from the future Penney building) in the "First Store in Seattle with electric lights" and the "First passenger elevator installed in a retail store in Seattle." But as Frederick's and the Bon expanded in the 1950s, MacDougall's fell into also-ran status. It was closed in 1964 and demolished in 1971. (University of Washington [UW] Special Collections, No. UW 5213.)

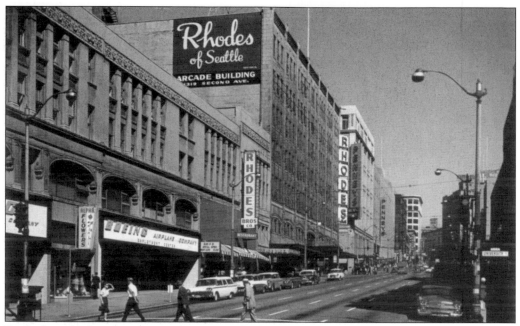

Back when Nordstrom was just a shoe store, Rhodes of Seattle at Second Avenue and Union Street advertised itself as "Seattle's Home-Owned Department Store." (The "of Seattle" differentiated it from a separate Rhodes in Tacoma.) Its customer services included a pipe organ to entertain customers. In 1965, it became part of M. Lamont Bean's Pay 'n Save Corporation. In 1968, Bean closed Rhodes' downtown store (it was razed in 2005 for the WaMu Center bank tower). (Deran Ludd collection.)

In 1970, Lamont Bean renamed Rhodes' suburban branches after himself. Lamonts, "Your Family Clothing Store," grew to 52 stores in five states by 1994. But its value-priced lines made it vulnerable to competition by larger chains such as Mervyn's. After Bean's empire broke up, Lamonts struggled independently until 2000. California-based Gottschalk's bought most of the remaining outlets. (From *View Northwest*, Pacific Publishing.)

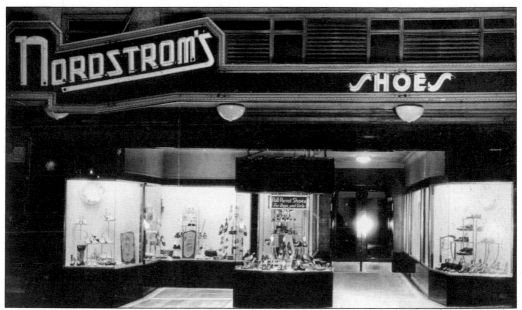

At its 1901 founding, and for many subsequent years, Nordstrom meant shoes, lots of shoes, and nothing but shoes. This 1935 image shows John Nordstrom and Carl Wallin's original location at Fourth Avenue and Pike Street. Two years later, the store moved a block east to Fifth Avenue and grew from there over the next six decades. (MOHAI, *Post-Intelligencer* collection, No. 1986.5.12079.1.)

In 1963, Nordstrom bought Best's Apparel, a women's clothing store, and later added menswear. A remodeled downtown store was completed in 1973. Designed by legendary local architect Roland Terry, it combined the old Nordstrom's and Best's buildings with a new middle structure. The design capitalized on this stuck-together nature to create a collection of semidetached "boutique" departments. Nordstrom moved from there into the former Frederick and Nelson building in 1998. (Seattle Public Library.)

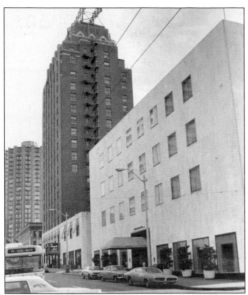

The I. Magnin apparel chain had a small Seattle branch beginning the 1930s. In 1954, it built this replica of its San Francisco flagship store, kitty-cornered from Frederick and Nelson on Pine Street. Magnin folded in 1993 and another San Francisco-based chain, Old Navy, now occupies the building. (UW Special Collections, Hamilton 2787.)

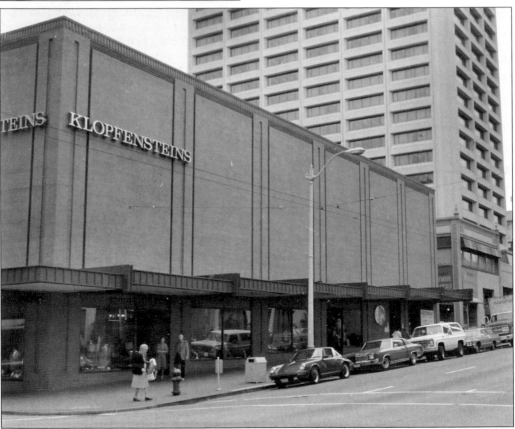

Klopfenstein's was one of Seattle's premier menswear shops, along with Littler and Albert Limited. Like those two stores, Klopfenstein's later added a women's department. In its latter years, it was owned by apparel makers Hart Schaffner and Marx. (UW Special Collections, Hamilton 2776.)

Jay Jacobs opened his first "store of fashion for young women" at Fifth Avenue and Pine Street in 1960. Six years later, Jacobs had added menswear, expanded his downtown store to three floors, and opened five suburban branches. The firm eventually grew to more than 300 stores throughout the west, but overexpansion and undercapitalization led to its 1999 demise. The downtown Jay Jacobs is now a Gap. (Seattle Public Library.)

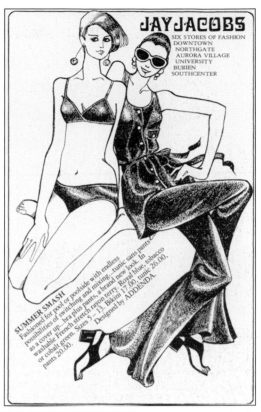

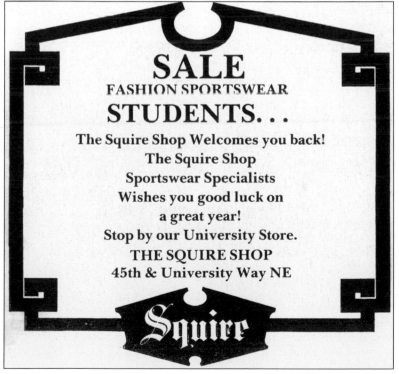

The first Squire Shop was a jeans store opened on University Way in 1970, at the peak of "youth culture." It advertised heavily on AM radio, grew into most area malls, and championed a once thriving local youth-apparel industry, selling such brands as Britannia, Generra, and Union Bay. (Advertisement from *UW Daily*, author's collection.)

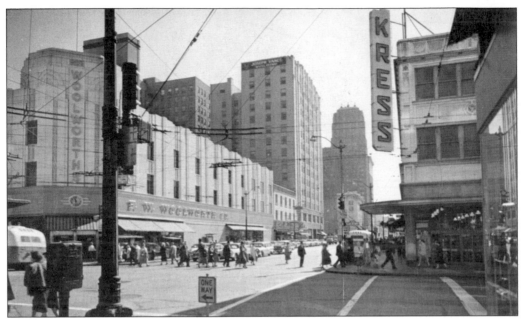

Woolworth and Kress, national archrivals in the dime-store genre, faced one another at Third Avenue and Pike Street for more than 40 years. When Woolworth opened its "Wonder Store" on Third Avenue in 1936, S. H. Kress had already been there since the early 1920s. Woolworth's offered everything from clothes and jewelry to candy and toys, all at bargain prices. The store's design welcomed its customers and pampered them as much as the "carriage trade" at ritzier stores. The downtown Kress closed in 1974; the building's current tenants include Starbucks. The downtown Woolworth closed in 1994; the site's now a Ross Dress for Less. (Above, Deran Ludd collection; below, MOHAI, PEMCO Webster and Stevens Collection, No. 1983.10.16460.)

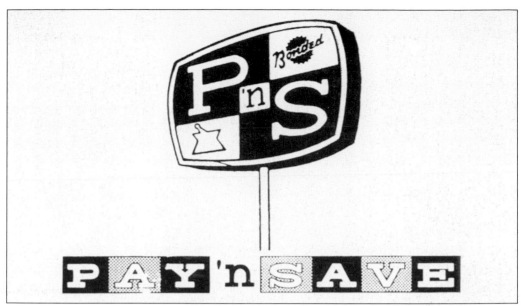

M. L. Bean opened his first Pay 'n Save drugstore at Fourth Avenue and Pike Street in 1941. At its peak, under the founder's son M. Lamont Bean, its bright blue and green stores reached 350 locations in 11 states. However, Bean lost control of his companies to New York financiers in 1984, and they sold Pay 'n Save to Portland's Pay Less Drugs, which later merged into Rite Aid. (From *View Northwest*, Pacific Publishing.)

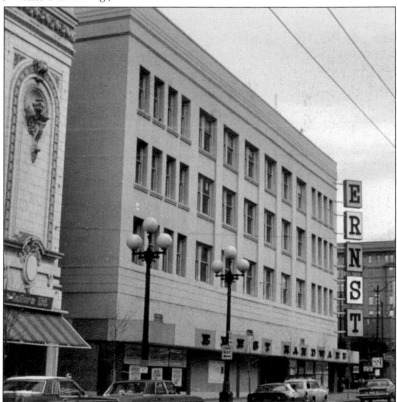

Fred and Charles Ernst started Ernst Hardware in 1889. It had already become a regional chain when Pay 'n Save bought it, merged it with Malmo Nurseries, and expanded it throughout the Northwest. Beset by big-box competition, Ernst was liquidated in 1996. Its downtown flagship at Sixth Avenue and Pike Street operated from 1907 to 1982. (UW Special Collections, Hamilton 3044.)

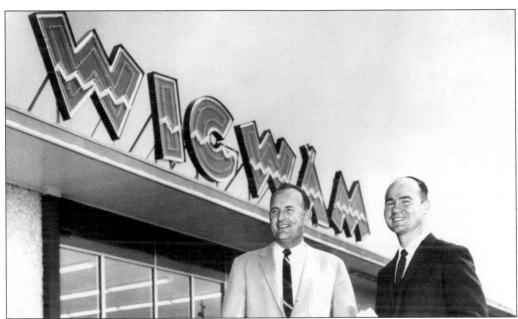

Wigwam, a chain of small-format discount stores, began in 1947. The *Seattle Times* wrote that it was "owned by five local residents, four men and a woman: Lillian Titel, Lloyd Adler, Homer Powell, Marvin Shelby and Dallas Ortman." Above, managers Gordon L. McLeod and C. J. Phillips open Wigwam's 15th Washington store in Puyallup in 1966. (Tacoma Public Library, Richards Studio Collection, D149234-1.)

Gov-Mart pioneered the membership-retail concept, which Costco, another Seattle firm, later made big. Cofounded by parking lot king Joe Diamond, Gov-Mart was initially open only to government employees and their families. Its first store was in Belltown's old Trianon ballroom (page 61). It expanded throughout the region (including the former Playland amusement park site, pictured on page 100), formed a joint venture with Portland's Ba'zar chain, then sold out to Pay Less Drugs. (UW Special Collections, Pamphlet Collection.)

These two variety stores on Aurora Avenue have arrow signs pointing in different directions, belying their joint future. By 1975, the Valu-Mart and Marketime chains would both be absorbed by Portland mass merchandiser Fred Meyer. (Shoreline Historical Museum.)

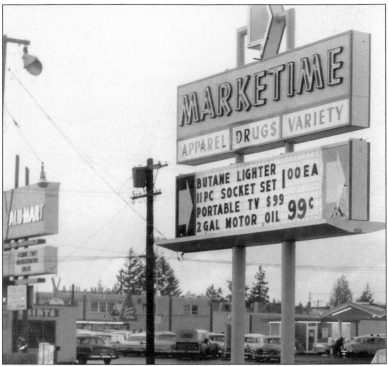

Larry Jaffe started Jafco as a "catalog showroom" on Westlake Avenue, specializing in sporting goods, casual furniture, home electronics, cameras, wine, toys, gifts, and jewelry. By the 1970s, it was part of the national Modern Merchandising chain, which Best Products bought in 1982. Best closed the former Jafco locations by 1996. (Seattle Public Library.)

23

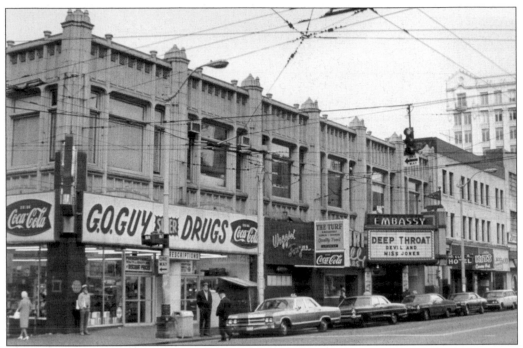

George Omar Guy claimed to have invented the ice cream soda in 1872 while clerking at a Philadelphia drugstore soda fountain. He came to Seattle in 1893 and opened his first G. O. Guy drugstore at Second Avenue and Yesler Way. By 1934, it had become a 24-hour operation. The Guy chain later struggled in competition with Bartell Drugs and Pay 'n Save; it slumped along until the 1980s. (UW Special Collections, Hamilton 3-36.)

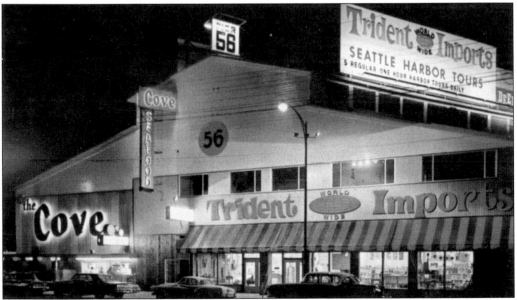

Trident Imports, which opened on Pier 56 in 1963, was a scavenger's delight. The old warehouse was stuffed with rattan furniture, piñatas, waterbeds, posters, mod floor lamps, wicker room screens, and more. After founder Charles Peterson's 1991 death, his daughters kept Trident going for six years. (Deran Ludd collection.)

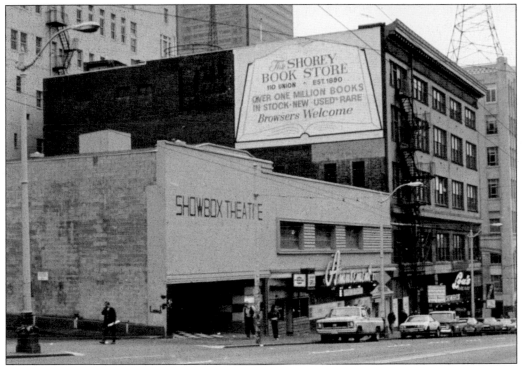

Samuel Shorey Books began selling used and antiquarian volumes in 1890. Shorey's moved often over the years, amassing as many as one million volumes. In 2000, it closed its last storefront in Fremont and went exclusively online but then disappeared altogether. This Union Street site is now the William Traver Gallery. Also pictured here are the Showbox, an indie-rock showplace, and the Amusement Center, precursor to today's Lusty Lady peep show. (UW Special Collections, Hamilton 2918.)

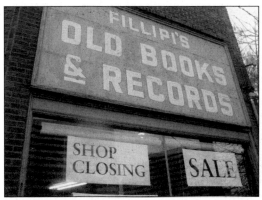
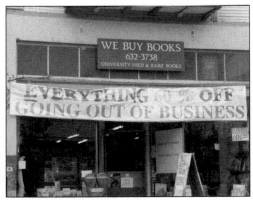

Other Seattle used-book giants included Fillipi's Old Books and Records on west Capitol Hill and Beauty and the Books (later University Used and Rare Books) on University Way. Both fell victim to rising rents and online competition in recent years. (Author's collection.)

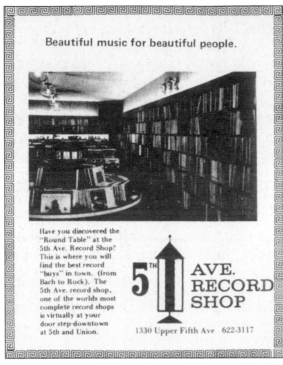

John Erling's Fifth Avenue Record Shop was Seattle's most comprehensive music store from the 1940s through 1981 and was one of the first places in town where whites, blacks, and Asians intermingled and exchanged artistic ideas. Its last owner, Jack Graves, moved it to Fourth Avenue inside Rainier Square.

Russ Battaglia and Bruce Pavitt opened Fallout Records and Skateboards on Capitol Hill in 1984. Pavitt soon left to tend to another of his ventures, the Sub Pop record label. Battaglia nurtured Fallout as a source for eclectic sounds from rock to jazz to R&B. Tim Hayes bought Fallout in 1999 and closed it in 2003. (Author's collection.)

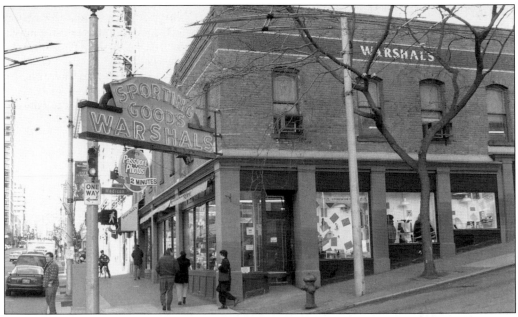

From 1922 to 2001, Warshal's Sporting Goods on First Avenue sold hunting, fishing, and camping gear, as well as bicycles, cameras, guns, and outdoor wear. The *Post-Intelligencer* called it "a place that echoes of plaid wool shirts, fishing gear and hunting garb." (Author's collection.)

O. H. "Doc" Freeman opened his boating supply store on the north shore of Lake Union in 1928. Freeman and his staff kept a huge inventory and maintained a high rapport with commercial and pleasure boaters. Competition from catalog and online suppliers, and the local decline of commercial fishing, hastened Doc Freeman's 2003 closure.

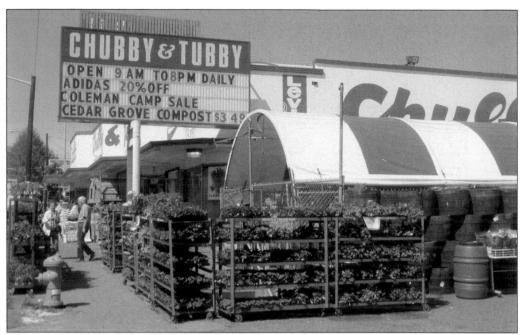

Woodrow Auge and Irving Frese opened Chubby and Tubby in 1947 as a war-surplus store that grew into fabulously cluttered variety-hardware-garden stores in the Rainier Valley, White Center, and Aurora (pictured here). It was famous for its discount Christmas trees, starting at 99¢ in the 1940s and rising only to $6 by its 2002 closing. (Author's collection.)

Ruby Montana's Pinto Pony opened in 1979, selling delightfully kitschy toys, posters, knickknacks, and home furnishings. *Monk* magazine said Montana "perfectly represents a type of good-natured tongue-in-cheek sensibility that might very well be characterized as Seattle Style." She also founded a Spam carving contest during Pioneer Square's Fat Tuesday promotion. In 2001, Montana decamped to Palm Springs, California, where she runs a retro-roadside resort. (Author's collection.)

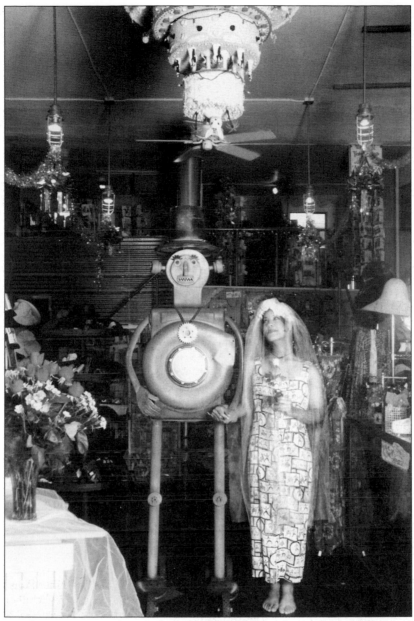

Charlotte Buchanan came to Seattle from Idaho in 1990 and soon opened the kitschy fashion and gift boutique Glamorama. It was the first store in Fremont to stay open until 8:00 p.m. It also featured an in-store wedding chapel, situated beneath a hanging, upside down wedding cake. On Valentines Day 1999, 32 couples exchanged or renewed their vows in ceremonies officiated by Buchanan (a Universal Life Church mail-order reverend) and an Elvis impersonator. They were among Buchanan's many infectious events for the store and the neighborhood, including the Fremont Oktoberfest and the Center of the Universe Ball. She spearheaded the drive to move a metal rocket sculpture to Fremont from a defunct Belltown surplus store and cofounded the Fremont Outdoor Cinema, offering weekly summer movie screenings in a cleared-out parking lot on a bring-your-own-chair basis. Buchanan closed Glamorama in 2000; she now runs another outdoor cinema in Arkansas. (Charlotte Buchanan collection.)

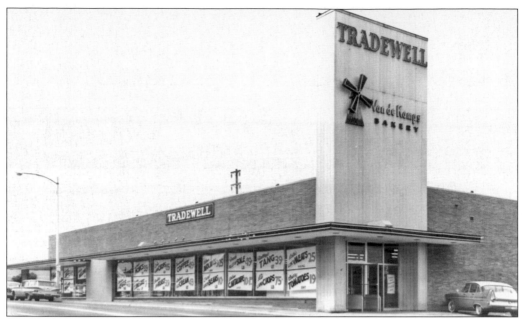

Herman and Minnie Eba opened a Pike Place Market food stall in 1910. In 1929, they opened Eba's Grocery in the market, which became the first Tradewell store. Later owned by wholesaler Pacific Gamble Robinson, Tradewell comprised 95 supermarkets at its peak, including several under the Prairie Market discount brand. The last 28 Tradewells closed or were sold in 1988. (Tacoma Public Library, Richards Studio Collection, No. A127820-10.)

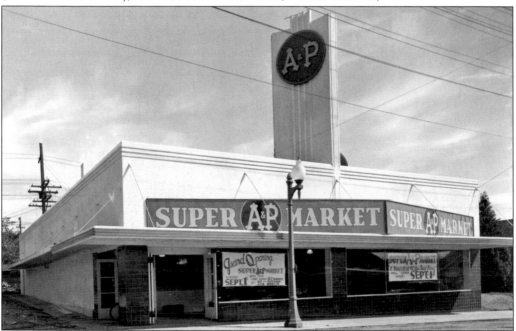

The Great Atlantic and Pacific Tea Company (A&P), once America's largest grocery chain, operated stores in Seattle from 1938 to 1974. A&P's departure from the Northwest was the first step in its contraction into a small northeast regional brand. (MOHAI, PEMCO Webster and Stevens Collection, No. 1983.10.13963.)

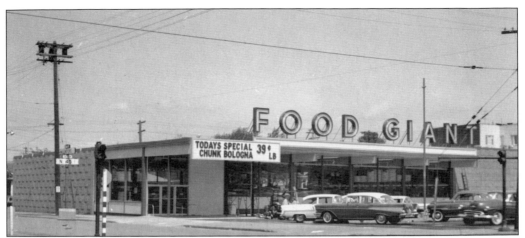

Frank Wald opened a small Wallingford grocery in 1948. Two years later, Wald's Market grew into a Foodland supermarket, which Leo Haskins bought in 1956, renamed Food Giant, and soon replaced with a bigger structure. Its flashing neon sign was a neighborhood landmark for almost four decades. (Puget Sound Regional Archives.)

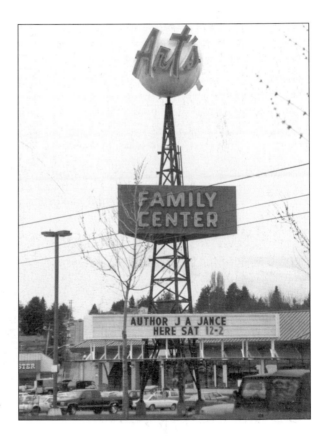

Arthur Case opened Art's Food Center on Holman Road in 1956, next to a Marketime. The *Seattle Times* called the building "one of the largest areas under a single roof west of the Mississippi." When Fred Meyer pulled Marketime out of its half of the structure, Case expanded into the whole building as Art's Family Center. Art's and Food Giant were both acquired in the 1990s by QFC, which was acquired by Fred Meyer, which was acquired by Kroger. (Eileen Massucco collection.)

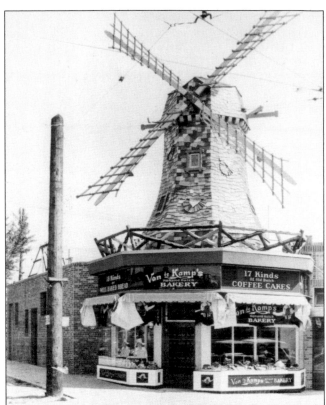

Van de Kamp's Dutch Bakeries ran this windmill-themed store, staffed by ladies in traditional Dutch-style blue uniforms and white hats, on Queen Anne Hill in the 1930s. Van de Kamp's later operated sections inside area supermarkets until the 1980s. A California firm now uses the name on frozen dinners. (UW Special Collections, Hamilton 1638.)

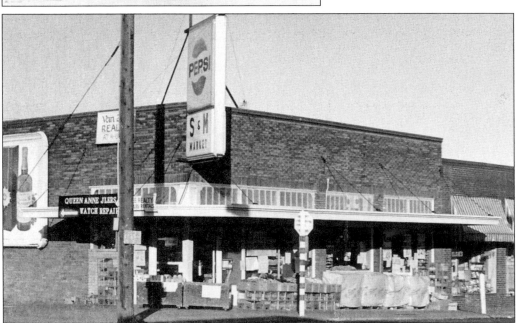

The S&M Market operated on upper Queen Anne from 1933 to 1989, by which time it might have sold more logo T-shirts than groceries. The name aside, it was a basic mom-and-pop food mart run by the Turkish Mezistrano family, complete with open-air produce bins outside. (UW Special Collections, Hamilton 943.)

Two

Restaurants

There was a time when downtown Seattle still had Penney's and didn't have penne. The city's restaurant scene used to be less concerned with pretense and more concerned with pleasure. A hearty, if unadventurous, meal at a reasonable price could be had most anywhere. Even the ritzy expense-account eateries mainly stuck to such basic American favorites as steak, seafood, and chicken.

In the late 1940s, full-service restaurants in Washington could start serving liquor, as long as they earned a certain portion of their revenues from food. This move both increased restaurateurs' profit potential and spurred them to devise higher-end menu items.

Fast food arrived in force in the mid-1950s, initially from local entrepreneurs. (Washington was the 43rd U.S. state to get a McDonald's.) Chain restaurants showed up in the 1960s, but so did the seedlings of a more educated, sophisticated approach to cooking and eating.

The 1970s saw many faddish fern-and-foliage places with too-cute names. At one point, there was a Hungry Turtle, a Velvet Turtle, and a Turbulent Turtle, each with different owners. The same era boasted such non-compact restaurant names as "Clinkerdagger's Bickerstaff's and Pett's Public House." Serious gourmet dining options exploded at this same time, along with a young, professional audience eager to try them.

Then came the seasonal New American bistros, the pan-Asian fusion, the hummus-laden appetizer plates, the celebrity chefs, and the just-invented "traditional Northwest cuisine."

Seattleites have a wider variety of dining choices than ever, including more fresh and organic ingredients. But it's good to remember where Seattle's been, and that path starts at one restaurant where all roads once led.

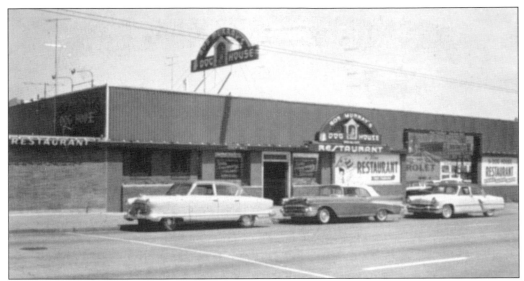

Bob Murray, a nightclub and wrestling promoter, opened the Dog House in 1934. With Murray's showmanship skills and a prime location at Denny Way and Highway 99, it soon became Seattle's top "roadhouse" restaurant. After several successful years, Murray's landlord decided he'd rather run his own restaurant in the space. (The new establishment failed, and the building housed a striptease club in the 1990s.) Murray relocated nearby to larger quarters at Seventh Street and Bell Avenue. The new space featured a cartoon mural of the "All Roads Lead to the Dog House" theme behind the counter. The walls held enlarged sepia photographs of Seattle streetscapes, which were new when they were first hung and extremely nostalgic by the 1990s. (Above, Deran Ludd collection; below, MOHAI, No. MP940102-7.)

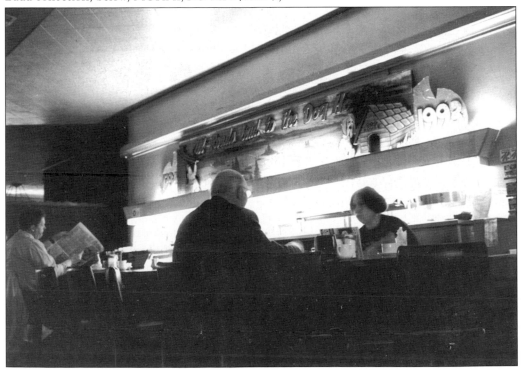

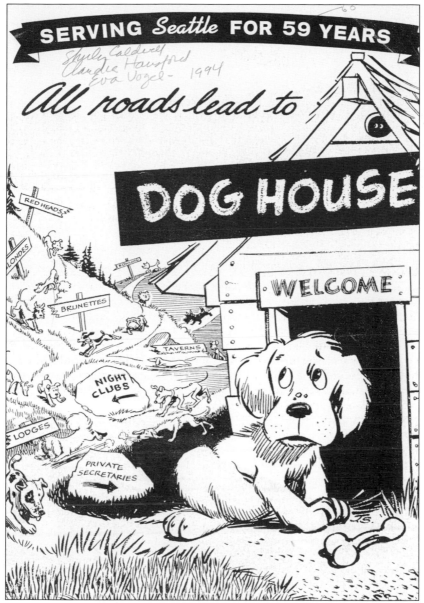

Post-Intelligencer writer John Hahn called the Dog House a place of "non-stop open-24-hours food, booze, music, and fellowship." Its menu offered goofy names for some items, such as the Bulldog and Pooch sandwiches, and warnings for others; the rib eye steak came with the disclaimer "Tenderness Not Guaranteed." The waitstaff wore prim black-and-white uniforms, and the lounge featured sing-along organ music, led by Dick Dickerson since the 1970s. After Murray's death, his widow handed control to longtime manager Laurie Gulbransen. She was succeeded by her son David, who had performed under the name "Rio de Janeiro" in the glam-cabaret troupe Ze Whiz Kidz. Faced with rising competition and costs (the Dog House was one of Seattle's last unionized restaurants in its price range), David shut it down in January 1994. The closing hour was telecast live by PBS affiliate KCTS. New owners reopened the Dog House building as the Hurricane Café. It is still open today but without the decor, the staff, or the atmosphere that made the Dog House great. (Seattle Public Library Seattle Room.)

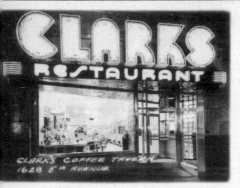

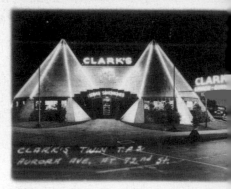

IN SEATTLE

IT'S *Clark's*

FOR FINE FOOD

AND COURTEOUS

FRIENDLY SERVICE

In 1916, Walter Clark got his first restaurant job as a coffee clerk at Manning's (page 39). From 1930 to 1970, Clark owned 55 restaurants—as many as 20 were open at any one time, and almost every one had a different name and menu concept, ranging, as a company slogan put it, "From Burgers to Chateaubriand." He started most of them from scratch; one exception was the Twin Teepees (page 2), which Clark owned from 1941 to 1954. Clark also owned office-building and factory cafeterias, a catering service, and the food concession on Washington State ferries. In 1970, the 74-year-old Clark sold his companies to Campbell Soup. The out-of-state bean counters proved ineffective at running the individualistic Clark's outlets, and they were closed or sold to new local owners, mostly one or two at a time. (UW Special Collections.)

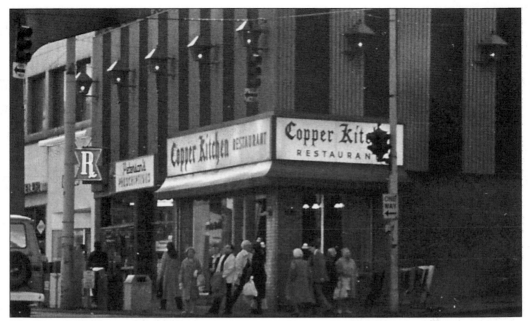

The Copper Kitchen on Westlake Avenue was one of Scotty Watts's three downtown restaurants; Peppermill and the Dutch Oven were the other two. Novelist Matt Briggs's parents first met there while his mother was a waitress. As Briggs describes it, "Watts's waitresses wore mustard-colored dresses and hats that looked like mushrooms. Because the top-heavy hats fell into people's soup, none of the waitresses wore them." (UW Special Collections, Hamilton 2249.)

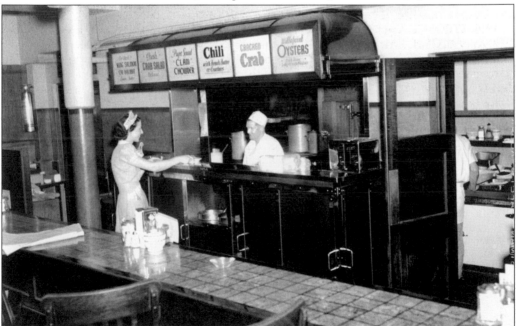

Ben Paris operated a restaurant, lounge, barbershop, and sporting-goods store on Fourth Avenue, which featured a large glass tank with live bass, and a smaller branch (seen here) on Pike Street. They were bastions for local fishermen and hunters. Paris also promoted fishing derbies and published a Northwest fishing guidebook. (Seattle Municipal Archives.)

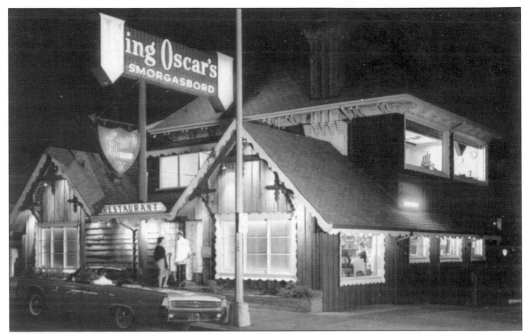

King Oscar's Smorgasbord on Aurora Avenue (advertised as the "House of the Artesian Coffee Pot") was one of the few major Scandinavian-themed restaurants in a city known for its large Nordic population. It operated from the late 1950s through the mid-1970s. (Author's collection.)

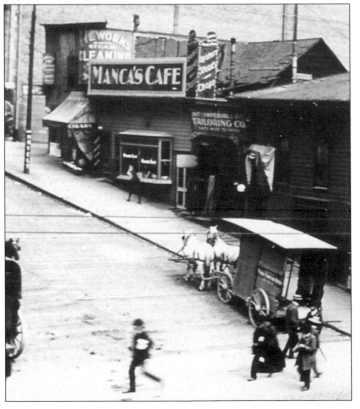

Manca's Cafe, pictured here at Second Avenue and Cherry Street around 1900, remained a downtown institution for nearly 60 years. Its specialties included miniature "Dutch Baby" pancakes. Another Manca's operated in Madison Park through the 1980s. Members of the Manca family are still prominently involved in local restaurants and catering companies. (UW Special Collections, Hamilton 3206.)

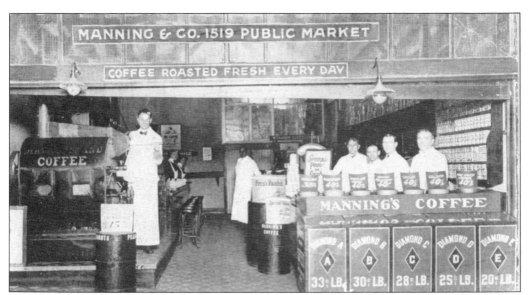

Manning's, a short-order restaurant and coffee-bean store, opened in the Pike Place Market in 1914. The company had coffee shops and delicatessens from Seattle to Los Angeles; its coffee was sold in groceries throughout the West. The last Manning's-owned restaurant, in Ballard, became a Denny's in the late 1970s. The original Pike Place location is now Lowell's. (Author's collection.)

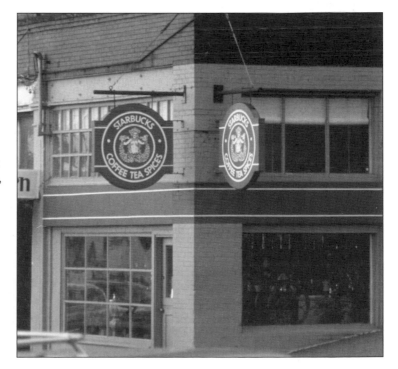

In 1971, Gordon Bowker, Gerald Baldwin, and Zev Siegl started Starbucks Coffee as a bean and machines store at the north end of the Pike Place Market. It did not initially serve beverages, but it did re-brand European-style coffee as an accoutrement to a young, professional lifestyle. When the original building was razed, the store moved one block south; that location remains the official "First Starbucks." (Seattle Municipal Archives.)

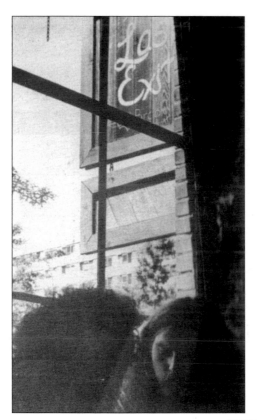

There were already several University District coffeehouses when Irv Cisky opened the Last Exit on Brooklyn in 1967. It became famous for cheap food, folk music, and bohemian conversation. This uncredited photograph from the *UW Daily* was one of the few Cisky allowed to be taken inside. After Cisky died in the early 1990s, new owners moved it to upper University Way, where it closed in 2000. (Author's collection.)

A neon sign in Coffee Messiah's window proclaimed "CAFFEINE SAVES," and crucifixes and gargoyles decorated the interior. Howard Bialik bought it in 1999 as an espresso station, bakery, vegan cafe, and gathering point for Capitol Hill subcultures from lesbians to Goths. Bialik, who threw public "coffee hexes" against a Starbucks two blocks away, sold Coffee Messiah in 2004; it closed in early 2006. (Author's collection.)

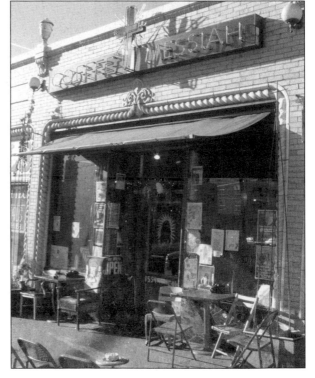

Brothers Michael and Tyler Apgar and Michael's wife, Gretchen, opened Seattle's first Internet cafe in June 1995. Located in the same Belltown building as the relocated 211 Club pool hall, the Speakeasy Cafe was a vast yet comfortable room serving coffee, pastries, sandwiches, beer, and wine. Users signed up at the counter for access to one of a bank of computer terminals. A back-room performance space hosted musical and theatrical shows. Three months after the cafe's opening, its owners expanded with Speakeasy.net, offering inexpensive e-mail accounts and home dial-up Internet access. As the home Internet business skyrocketed, the cafe's user terminals became less busy and the cafe's menu was pared down. The Speakeasy burned in an electrical fire on the night of May 18, 2001, and the building was razed five years later. Speakeasy.net's offices and technical headquarters had already moved a block away before the fire; the company now offers broadband connections for homes and offices nationwide. (Author's collection.)

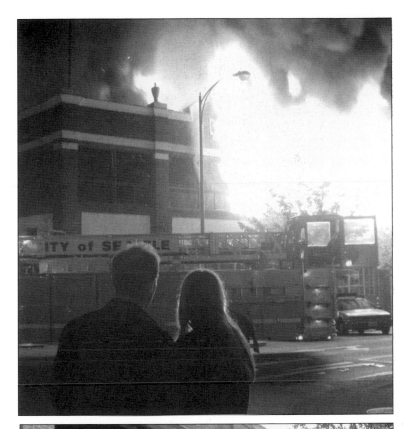

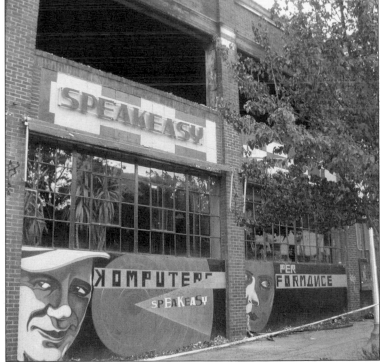

We're as square as our hamburgers

We, the new local owners of Herfy's, can't begin to match our big, well-heeled competitors when it comes to advertising bucks, so instead we put more value into our food. Here are just four of the ways we do it.

1 **20% More Pure Beef in Regular Hamburgers and Cheeseburgers at No Increase in Price.** That's the same size patty Leon Gardner used when he started Herfy's in Everett back in 1962 (and it happens to be 20% larger than most of our heavily advertised competitors).

2 **The Original Hefty with Original Hefty Sauce.** That's the two-patty sandwich, with ¼ lb. of beef (uncooked weight), on which Leon built the business. We're bringing the Hefty back to its former glory, as we said, with *20% more beef, no increase in price*, and the same special sauce that Leon originally developed with the Nalley's folks in Tacoma.

3 **New ⅓ lb. Bacon Burger.** We decided that if we were going to have a big Colorado beef burger we would do it right! One-third pound (uncooked weight) beef, with or without cheese, crisp bacon, nice thick tomato slices, lettuce, and a touch of our special Hefty sauce.

4 **New Chicken Patty Sandwich,** lightly breaded all white meat, cooked to order and gently placed in a new style long, French-style roll with sesame seeds, along with lettuce and mayonnaise.

THE NEW ORIGINAL

Herfy's

In 1962, Leon Gardner started the first Herfy's Hamburger House in Everett. The chain, with its steer's head logo, expanded throughout western Washington. Campbell's Soup bought Herfy's in 1970 (just before it bought Clark's) and resold it to local operators a decade later. The chain was liquidated in 1986, and the original Everett flagship closed around 2002. A new, unconnected Herfy's chain has emerged in recent years. (Advertisement from *UW Daily*, author's collection.)

Local advertising agency Cole and Weber created a musical commercial for Sea Galley, a franchise seafood chain begun in the mid-1970s, featuring the jingle "We've Got Crab Legs!" and dancing chorus boys in crab-limb pants. The company was less successful with its next concept—the Flakey Jake's gourmet burger chain. The last Sea Galleys were liquidated in 1996. (From *View Northwest*, Pacific Publishing.)

The Best Seafood At Any Price

12 Great Seafood Dinners From $4.95!

N.E. 24th Ave. and Belle-Redmond Road—Bellevue

On 25th N.E. across from University Village—Seattle

19619 Lynnwood Shopping Center Lynnwood

Sea Galley

FOR GREAT SEAFOOD, STEP INTO A GALLEY.

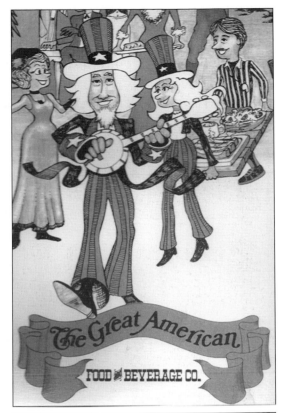

Jerry Kingen grew up in a restaurant family. In 1970, he bought the Red Robin, a small tavern on the south end of the University Bridge, and turned it into the flagship of a "gourmet burger and spirits" chain (now headquartered in California). As the Red Robin chain grew, Kingen also operated several stand-alone "fern bar" restaurants, including The Great American Food and Beverage Company, Lion O'Reilly's and B. J. Monkeyshines, and Boondocks, Sundeckers, and Greenthumbs. O'Reilly's was particularly famous as Capitol Hill's top heterosexual pickup bar. But all were gone by the mid-1980s. Kingen later co-owned a SeaTac casino and now runs the three-outlet Salty's chain. (Seattle Public Library Seattle Room.)

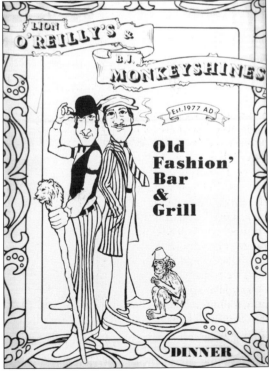

German immigrant Guenther Woerne opened Woerne's European Pastry Shop on University Way in the early 1960s. A favorite lunch and snack spot, its specialties included schnitzel, whole-wheat spinach croissants, and Viennese pretzels. The shop is still open but without Woerne's name or many of his specialties.

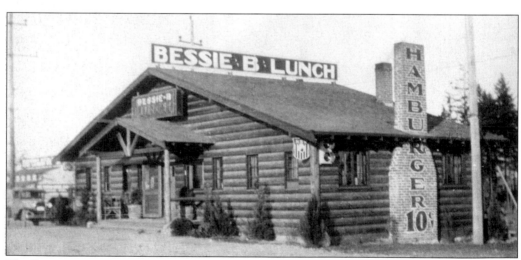

The Bessie B Lunch, with its log cabin-esque exterior, was the leading coffee-shop restaurant in Richmond Highlands (later Shoreline) from the 1920s through the 1950s. The building later became an appliance store. Built on old Interurban Railway right-of-way, it was razed in 2004 for a hiking and biking trail. (Shoreline Historical Museum.)

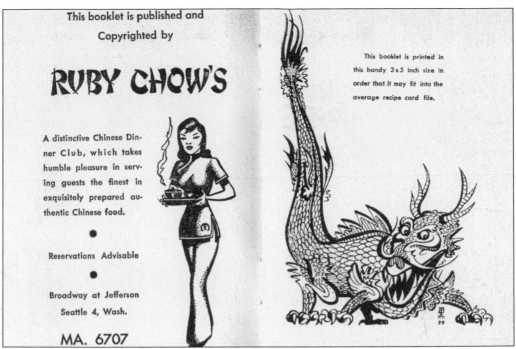

Ruby Chow, whom writer Todd Matthews described as "barely five feet tall with a towering French roll," opened her namesake restaurant in 1948. At Broadway and East Jefferson Street, it was Seattle's first big Chinese restaurant outside of Chinatown. A young Bruce Lee once worked in the kitchen. Chow later became the first Asian American on the King County Council. She and her husband, Ping, sold the restaurant in 1979. (Author's collection.)

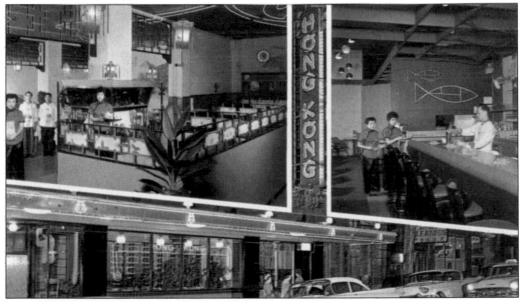

Before Chow opened her own establishment, she tended bar at the Hong Kong restaurant, a 1910-built building on Chinatown's Maynard Avenue. The restaurant closed in the early 1980s and has remained vacant ever since. The Wing Luke Asian Museum now owns many of its artifacts. (Deran Ludd collection.)

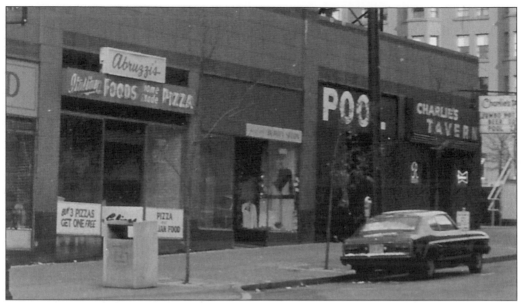

Abruzzi's Pizza on Pike Street was a down-home family slice-and-pie joint amid an increasingly slick downtown dining scene. It was demolished around 1996. *Seattle Weekly*'s Rick Anderson quoted Nick Abruzzi, upon hearing he'd lost his lease for an athletic-wear megastore, "Niketown? What's that, a home for lost tennis shoes?" The same building housed Charlie's Tavern, which was featured in the film *House of Games*. (UW Special Collections, Hamilton 3046.)

Save $2
on Pizza Haven home delivery.

Limit one coupon per delivery.
Subject to normal delivery charge
and normal delivery routes.
Expires August 31, 1980.

University	4231 University Way NE	633-5311
Northgate	543 NE Northgate Way	364-7060
Broadway	112 Broadway E.	322-6300

Ron Bean (nephew of Pay 'n Save tycoon Lamont Bean) opened his first Pizza Haven on University Way in 1958, becoming one of the Northwest's first chain pizzerias, with 42 restaurants and a home-delivery operation. As bigger chains moved in, Pizza Haven shrank to a slice stand in the Seattle Center House. (From *UW Daily*, author's collection.)

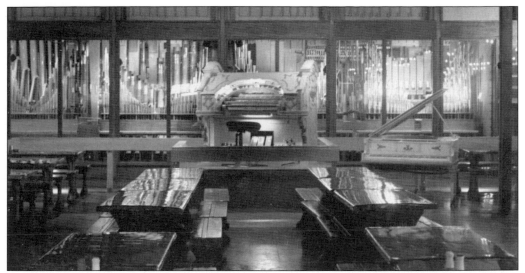

Bill Breuer's California-based Pizza and Pipes chain came to Seattle's Greenwood neighborhood in 1973. Its centerpiece was a 1930 Wurlitzer pipe organ, played by a crew of staff organists. It closed in the late 1980s; the organ was bought by a private collector. (Tom Blackwell collection, Puget Sound Theater Organ Society.)

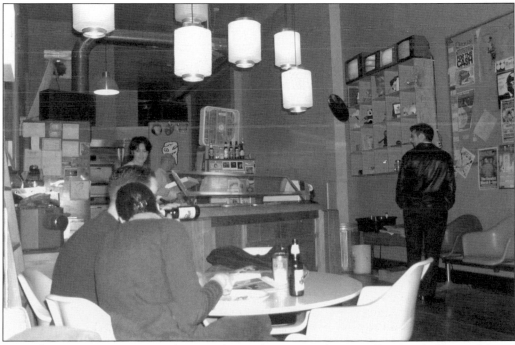

Second Avenue Pizza was opened in March 1998 by musician/artists Jeffrey Smith, Darren Morey, and Susan Robb. The front room served slices, pastries, and beer in a retro-mod atmosphere; the back room hosted rock bands and movie screenings. Raine La bought it in 2003 and closed it a year later. (Author's collection.)

In 1969, Julia and Francois Kissel took a worn-down Pioneer Square diner, Pittsburg Lunch, and turned it into a fancy French eatery, Brasserie Pittsbourg. Some consider it the start of the neighborhood's commercial renaissance and of a new generation of Seattle gourmet restaurants. The Kissels later opened Maximilien in the Pike Place Market, which is still in business today. (Seattle Public Library.)

Lori Lynn Mason opened the Fremont coffee stand ETG (Espresso To Go) in the early 1990s, then added a full restaurant, the Longshoreman's Daughter (which she was), two doors down. The menu specialized in sandwiches and hearty breakfasts, and the walls featured muted-color mural collages of working, waterfront imagery. Mason closed the Longshoreman's Daughter upon moving to Los Angeles; ETG remains open. (Author's collection.)

Montana-born Jean Flynn acted and sewed costumes for Seattle theater groups before she opened the Western Coffee Shop on Western Avenue. Decked out in a retro-cowboy theme, the short-order spot was a popular hangout for artists and musicians. It closed in 1994. Flynn later worked on Hollywood movie sets and is now an interior decorator in Berkeley, California. (Jean Flynn collection.)

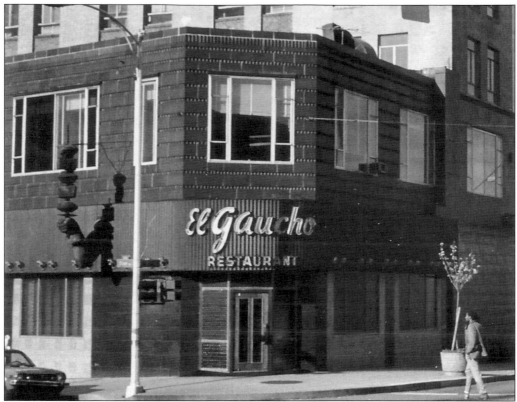

El Gaucho was started in 1953 by Jim Ward (who later started the still-extant 13 Coins). As the ground-floor restaurant in the Tower Building at Seventh Avenue and Olive Street, the steakhouse was often mentioned on air by KVI's radio personalities working upstairs. Years after its 1980s demise, Paul Mackay opened a new El Gaucho in Belltown, complete with a "cigar lounge." (UW Special Collections, Hamilton 2794.)

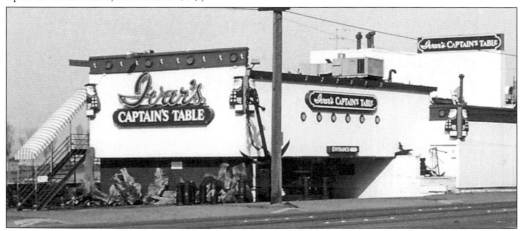

After Ivar Haglund (page 121) opened his Acres of Clams, he started another full-service restaurant, the Captain's Table, downtown. In 1963, he moved the Captain's Table to the former Crawford's Sea Grill on Elliott Avenue, in a more industrialized part of the Elliott Bay waterfront. It was quietly shut down (one of the few quiet things Haglund ever did) in the early 1980s. (UW Special Collections, Hamilton 3436.)

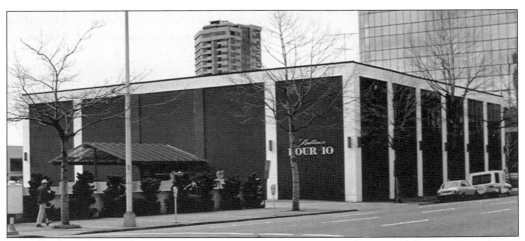

Victor Rosellini (1915–2003) opened Victor's 610 in 1950, followed in 1956 by Rosellini's Four-10 in the White-Henry-Stuart Building. The elegant "carriage trade" dinner spot became a prime hangout for local executives and politicians. (Victor's cousin Albert served two terms as Washington's governor.) The Four-10 moved to Fourth Avenue and Vine Street and closed in 1988. (UW Special Collections, Hamilton 4057.)

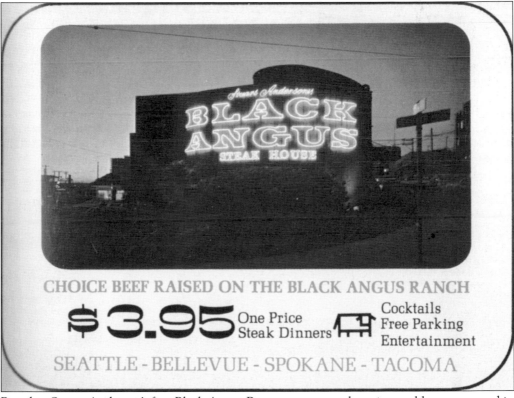

Rancher Stuart Anderson's first Black Angus Restaurant, a popular-price steakhouse, opened in 1964 in the Caledonia Hotel downtown. It soon moved to Elliott Avenue and spawned a chain that peaked at 121 locations in 18 states. The Elliott Avenue location closed in the early 1980s and burned in the mid-1990s. The chain is now headquartered in California. (From *Seattle Guide*, Sunny Speidel collection.)

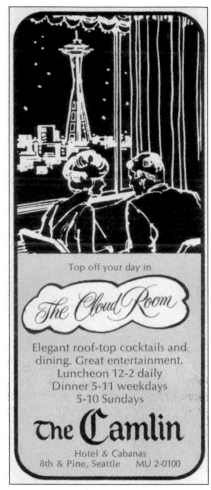

The Space Needle could be briefly seen from portions
of the Cloud Room, atop the 11-story Camlin Hotel.
When the restaurant opened in 1949 (23 years into
the Camlin's existence), it offered spectacular views of
Elliott Bay and the Olympic Mountains. But even after
newer downtown towers blocked much of the view, the
Cloud Room kept its classy yet homespun charm. The
lounge's piano had a wraparound drink counter, and
pianist Gil Conte tickled the ivories for many years.
Many entertainers from the nearby Paramount Theater
performed impromptu sets, including Frank Sinatra,
Dean Martin, Miles Davis, and Bonnie Raitt. But the
hotel was unable to compete with chain hostelries.
Trendwest, a time-share resort operator, bought the
Camlin and closed the Cloud Room in 2003. (Above,
from *Seattle Guide*, Sunny Speidel collection; below,
author's collection.)

Three

BARS AND NIGHTCLUBS

From its frontier start, Seattle has always been of two minds regarding alcohol and nightlife. A wide-open saloon culture kept lumberjacks, sailors, and farm boys coming to town, bringing their money to Seattle bars (and to Seattle women). Moralists, however, preached that the city would be better off, economically and in other aspects, without all the noise and rowdy behavior.

Washington State enacted Prohibition in 1916, four years ahead of the nation. Repeal came with heavy regulations, intended to prevent any return of the saloon culture. Hard liquor could only be sold by the bottle in state-owned stores and could only be served by the drink in private clubs. Commercial bars served only beer and wine (mostly beer, as protectionist state laws kept most out-of-state wine brands away). These bars had to close by 1:00 a.m. and had to stay closed on Sunday.

The result was a plethora of small, plain, dimly lit neighborhood taverns, serving a mostly male clientele. One of these, Charlie's Tavern at Sixth and Pike Street, is pictured in the 1987 film *House of Games* when Lindsay Crouse's character remarks about "the need for dark places to transact dark business."

These restrictions eased slowly. Restaurants were allowed to add cocktail lounges in 1949, leading to an immediate boom in upscale steakhouses. Bars could open on Sundays starting in 1963.

Finally, in the 1990s, the state allowed cocktail lounges without attached restaurants. This change caused many big fancy lounges and music clubs to open, particularly in Belltown and Fremont. It has caused some residents in these neighborhoods to complain about noise and rowdy behavior. The cycle has gone full circle. Another round, anyone?

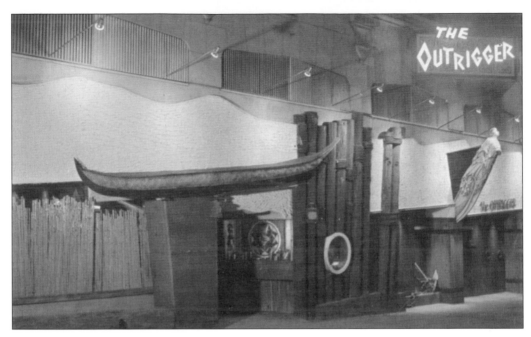

The Outrigger by Trader Vic opened in 1948 in the Benjamin Franklin Hotel on Fifth Avenue and marked Victor Bergeron's first expansion beyond his original Oakland, California, restaurant-lounge. It was later rechristened under the regular Trader Vic's brand and moved into the adjacent Washington Plaza (now Westin) hotel tower. Under beloved manager Harry Wong, generations came to adore its fruity and rummy cocktails, its pan-Asian entrees, its cute tableware, and its islander decor. The mai tais stopped flowing in 1991 when the Westin sought a more "serious" restaurant tenant. Some of the decor now hangs at Belltown's Crocodile Cafe. A new Trader Vic's opened in Bellevue in 2006. (Deran Ludd collection.)

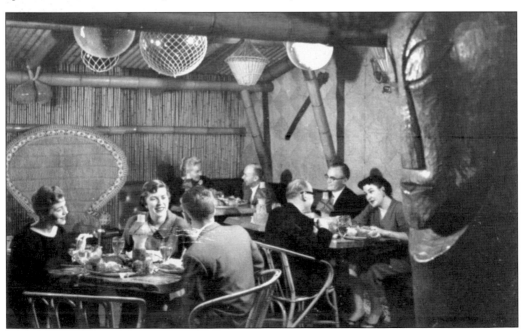

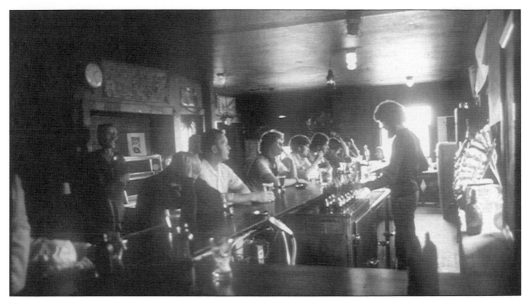

The Place Pigalle Tavern, informally known as Pig Alley, was the Pike Place Market's main watering hole for hippies and political activists in the late 1960s and early 1970s. Much of the "Save the Market" campaign originated from its barstools. By the time the market's restoration was complete, the tavern had given way to a fancy French restaurant under the same name. (Seattle Municipal Archives.)

Many of the old Pigalle regulars went on to lucrative professional careers. Most of greater downtown's 200 or so old beer joints, however, serviced ordinary working (and nonworking) folks, old-age pensioners, and guys waiting for that next big opportunity. Almost none of these establishments survive today. (*Pike Place Market News.*)

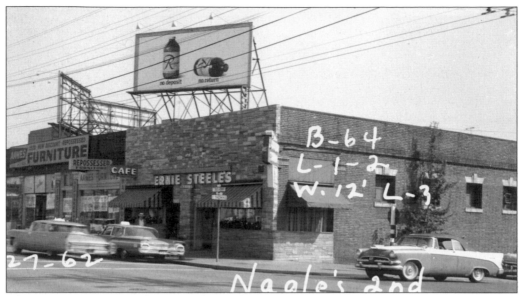

Ernie Steele, a former UW football star, opened his Checkerboard Restaurant and bar on Broadway in 1945. The *Seattle Weekly* later wrote that Steele ran "the quintessential old-man bar, serving eye-wateringly strong cocktails to a host of hard-drinking regulars." Ileen Schumaker took it over in 1991 as Ileen's Sports Bar and the Ernie Room. Her rent had increased more than fivefold by 2001 when she shouted last call. (Puget Sound Regional Archive.)

After the state eased its rules for hard-liquor establishments in the late 1990s, most of Seattle's remaining beer-and-wine-only joints either became cocktail lounges or folded. The Copper Gate in Ballard was one of the last to fall, closing in late 2005. (Author's collection.)

The Frontier Room was a quintessential dive bar for longshoremen and rockers alike. The *Seattle Weekly* once described head barmaid Nina Finelli as "famously, awesomely, gruesomely rude." The front restaurant served fresh-cut fries and real ice cream shakes. Jackie Lang-Hartwig, whose family had run the place for more than 50 years, shuttered it in July 2001. The name and neon survive on an upscale barbecue restaurant. (Author's collection.)

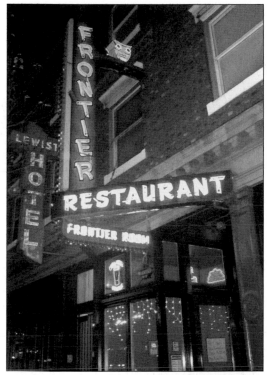

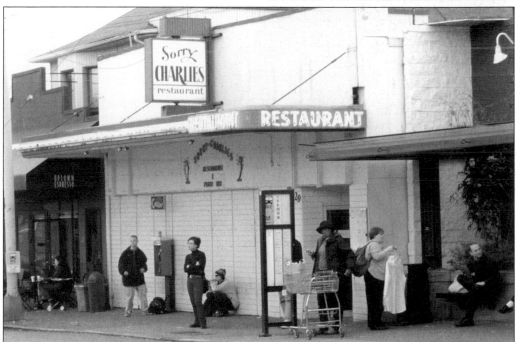

Sorry Charlie's opened on lower Queen Anne in July 1975. In 1987, it acquired its signature asset—piano-bar maestro Howard Bulson. It closed on Labor Day 2003. Bulson returned several times to perform at Sorry Charlie's replacement, the slicker and "hipper" Mirabeau Room. The Mirabeau closed in September 2006. (Author's collection.)

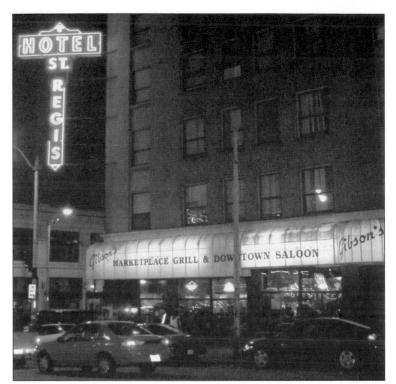

The Gibson House at the St. Regis Hotel opened in the early 1980s, as other lowbrow First Avenue bars had begun to close. In its early days, prostitutes often met clients in the bar, then led them to hotel rooms upstairs. The Gibson had become a rock club when its last owner, Tony Tsui, closed it without notice in mid-2001. The building's been rehabbed for low-income housing. (Author's collection.)

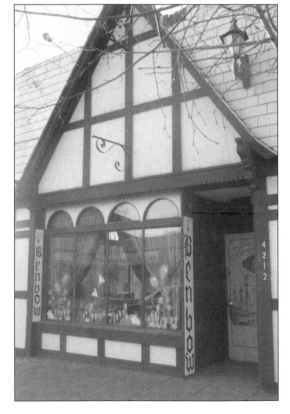

Lloyd Longmire opened the Admiral Benbow Inn on West Seattle's Admiral Way in 1950. A year later, he married waitress Neysa Nugent; she took over the restaurant-bar upon their 1968 divorce. Weekly newspaper *The Stranger* described its barroom as resembling "the dim, rolling interior of a Spanish galleon." When Neysa Longmire died in May 2002 at age 80, her heirs had already decided to close the Benbow. (Author's collection.)

The Hansen family shut down their Lower Queen Anne bakery plant (home of the local franchise for Sunbeam Bread) in the mid-1970s, seeking a more lucrative use for the real estate. They rebuilt the block as a mini-mall, still titled the Hansen Baking Company. Its flagship tenant was Jake O'Shaughnessey's, one of Mick McHugh and Tim Firnstahl's several huge, opulent steak-and-whiskey establishments. It once claimed to have the world's largest selection of single-malt Scotches. It closed, along with the rest of the Hansen mall, in 1993. A Larry's Market now stands on the site; McHugh ran a New Jake O'Shaughnessey's in Bellevue until 2001. (Above, UW Special Collections, Hamilton 501; below, Seattle Public Library.)

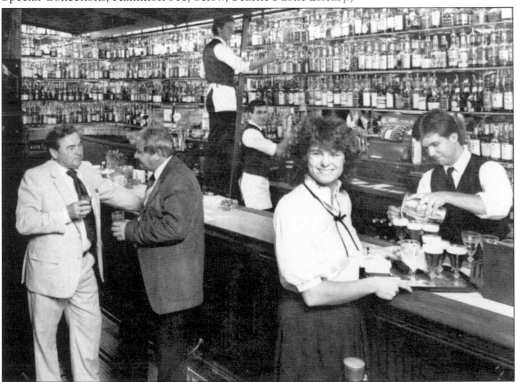

The Vault, run by jazz musician Ronnie Pierce from 1962 to 1976, was a booze-free, all-ages, live music club at Second Avenue and Union Street, beneath the original 211 Club (page 99). Go-go dancers joined the scene from 1966 to 1968. Many of the customers were navy men stationed in Bremerton. (Ronnie Pierce and Elaine Bonow collection.)

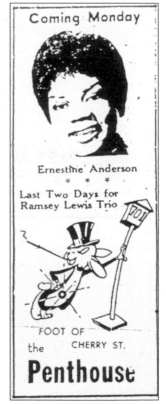

Coming Monday

Ernestine Anderson
* * *
Last Two Days for
Ramsey Lewis Trio

FOOT OF
the CHERRY ST.

Penthouse

Seattle music historian Paul de Barros has called Charlie Puzzo's Penthouse one of "the city's first true modern jazz clubs." The posh nightspot north of Pioneer Square hosted dozens of national and local stars during its 1960–1968 lifespan; John Coltrane recorded a live LP there.

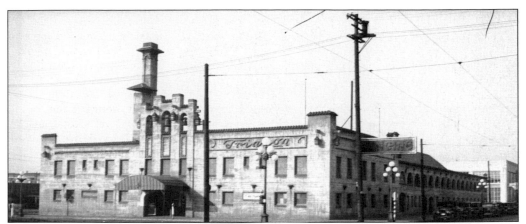

Jazz was booming, but booze was still banned when Belltown's Trianon Dance Parlor opened in 1928. It thrived as a major swing and big-band dance hall. Quincy Jones played there in 1949 with the Bumps Blackwell Junior Band. In 1956, retail replaced music as the building's lifeblood. The facade survives today, in front of an office building. (Puget Sound Regional Archive.)

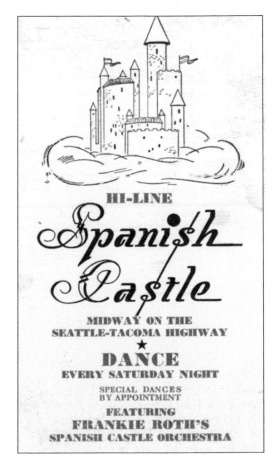

The Spanish Castle, on Highway 99 between Seattle and Tacoma, opened as a "roadhouse" dance hall in 1930. Surviving the switch from jazz to rock, it hosted a wave of local hit makers (including the Wailers, the Ventures, the Frantics, the Sonics, and a teenage Jimi Hendrix) until its 1968 demolition. (Seattle Public Library Seattle Room.)

TOGA Party

NO COVER CHARGE FOR PERSON WEARING TOGAS or PAJAMAS!

Wednesday - April 30

★ PRIZES
★ $1⁰⁰ BAR DRINKS 9 pm-11 pm

The Golden Tides

6017 Seaview NW
784-7100
Lunch from 11:30
Dinner from 5:30

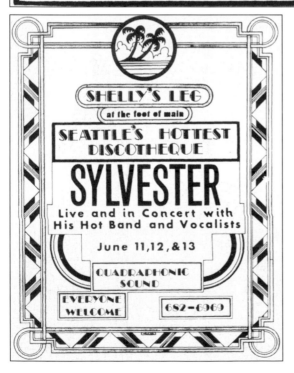

SHELLY'S LEG
at the foot of main

SEATTLE'S HOTTEST DISCOTHEQUE

SYLVESTER

Live and in Concert with
His Hot Band and Vocalists

June 11,12, &13

QUADRAPHONIC SOUND

EVERYONE WELCOME 682-6969

The Golden Tides in Ballard and Pier 70 on the waterfront, both run by Mark T. Mitchell, were among Seattle's biggest dance clubs in the 1970s. They featured both DJ nights and live music, mostly by cover bands. The Tides became an Azteca Mexican restaurant; Mitchell now runs a restaurant-casino complex in Shoreline. (From *UW Daily*, author's collection.)

A stray blast from a parade's cannon struck Shelly Bauman in 1970. Bauman lost a limb but won a settlement that enabled her to open Seattle's first gay disco, Shelly's Leg (opened in Pioneer Square in 1973). Sara Vogan later took its name (but nothing else about it) for a novel called *In Shelly's Leg*. The building was converted to condominiums. (From *Seattle Gay News*, Seattle Public Library.)

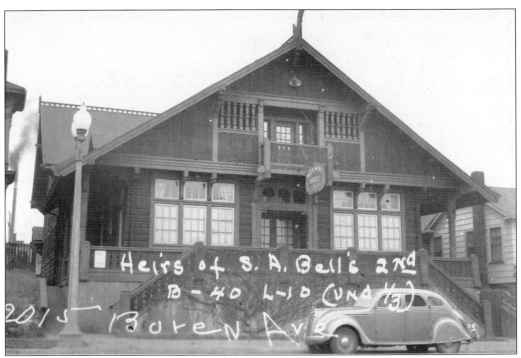

The City Beat (later known as Boren Street, and even later as Timberline) Disco was the local gay dance scene's first long-term success. Established c. 1974 in the 1903 Sons of Norway hall, it had the largest wood dance floor of any local club. Cornish College of the Arts took over the building in 2003. The Timberline moved to a former garage nearby but closed in 2005. (Puget Sound Regional Archive.)

In 1979, George Freeman bought a church building near the Boren Street Disco, bought a mail-order minister's license from the Universal Life Church, and opened The Monastery, whose "services" were all-ages, all-night dance parties. It became notorious for drugs, underage drinking, and intergenerational gay sex. In 1985, the city shut it down and enacted a "Teen Dance Ordinance," effectively banning most all-ages music events in Seattle for over a decade. A regular church reopened the building until the mid-1990s. (Mary Randlett collection.)

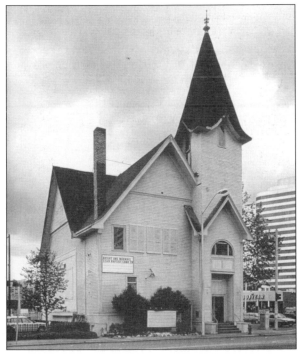

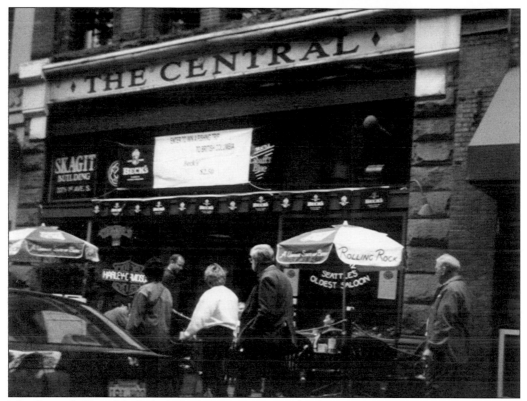

The Central, "Seattle's Only 2nd Class Tavern," traced its lineage to 1892. In 1977, owner Bobby Foster (a former Boeing engineer) founded Fat Tuesday, Pioneer Square's Mardi Gras promotion. Later owners, Mike and Donna Downing, brought in such future hit rock bands as Soundgarden and Alice in Chains. It's now the somewhat fancier Central Saloon. (Jeff Mecca collection.)

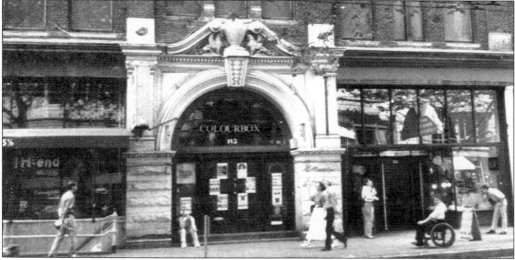

The Colourbox rock club in Pioneer Square opened in 1991, just as the Seattle rock scene was becoming world famous. It was in one of several area buildings owned by Sam Israel (1889–1994), who famously kept rents low by skimping on maintenance. By its 1999 demise, the Colourbox's leaky plumbing was as raunchy as any of its music. (Jeff Mecca collection.)

Wrex, a former leather bar in Belltown, was Seattle's top "new wave" rock club from 1979 to 1981. In 1983, it reopened as the Vogue, offering a mix of live bands (including Nirvana's first Seattle gig) and DJ nights. The Vogue moved to Capitol Hill in 1999; the Vain hair salon now occupies its old space. (Anonymous poster from *Instant Litter*, Art Chantry collection.)

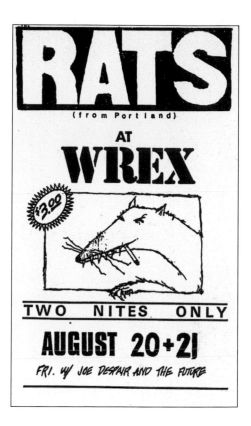

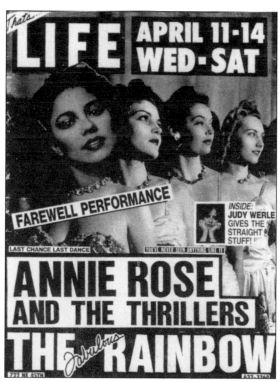

The Fabulous Rainbow in the University District was a top live-music venue from 1974 to 1987. At a time when most local clubs had strict genre-specific booking policies, the Rainbow would book experimental jazz, soft rock, R&B, and power pop all in the same week. (Poster by Rhoda Meuller from *Instant Litter*, Art Chantry collection.)

65

In 1993, when Lisa Bonney and Michael Rose started Sit and Spin in a former Belltown jazz club, they gave it everything—a restaurant, bar, live-music space, art gallery, and coin-op laundry, and it had classic children's board games on its walls. The place lasted a decade; the Spitfire sports bar is there now. (Author's collection.)

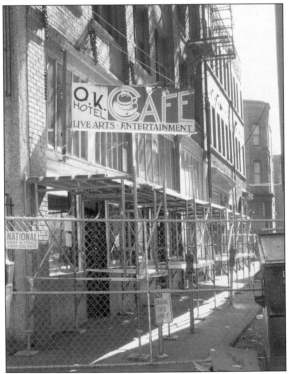

The OK Hotel, an old waterfront flophouse, was reopened in 1988 by Steve and Tia Freeborn as a cafe, gallery, and performance space. They later added a bar with a cabaret stage. An earthquake on Ash Wednesday 2001 shut the OK Hotel down. It has been reworked as apartments and art studios. The Freeborns now run another historic club, the Rendezvous in Belltown. (Author's collection.)

Four

BUILDINGS AND STREETSCAPES

To Seattle's first Caucasian settlers, a successful building was one whose roof did not leak. After the 1889 fire, builders sought a greater sense of permanence in their work. This early edifice complex, as seen in Pioneer Square, emphasized stone, brick, and weightiness.

Seattle came to follow, and sometimes influence, architectural trends, from terra-cotta palaces to Craftsman bungalows, from efficient modern boxes to grandiose postmodern "Big Statements."

Yet what many locals remember most are the odd, impractical, and playful structures that brought a welcome smile to passersby. They fondly recall the classic roadside architecture of the Twin Teepees, the commercial yet comforting neon pitches for bread and cookies, and the low-rise office buildings that did not need to loom over everyone to express their importance. Seattlites look back in wonder that a ferry dock could be an art deco beacon, or that the roof of a wartime Boeing factory could be disguised as a residential community complete with streets, houses, and picket fences. Even the utilitarian Kingdome, so often maligned before, during, and after its existence, draws at least a wistful memory or two from some former attendees.

Today tall hotels and taller condominiums move the cityscape ever higher. In the residential neighborhoods, old building lots are being joined together to fit mini-mansions or split up for duplexes. In newly designated "urban village" zones, residential-retail "mixed-use projects" replace old supermarkets and gas stations. And downtown, it's no longer enough for an office tower to be tall; it now has to be architecturally "significant," just like every other significant office tower in every city in the world. And its roof shouldn't leak.

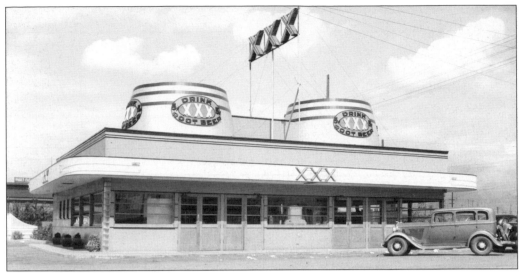

This "double barreled" aluminum structure is a XXX Root Beer Drive-In, *c.* 1940. The chain folded by the 1970s, but the Issaquah branch survives as an independent. Besides this and the Twin Teepees, Seattle had a third dual-building restaurant, the Igloo. Open on Denny Way from 1940 to 1954, it took the form of two white hemispheres. (Seattle Municipal Archives.)

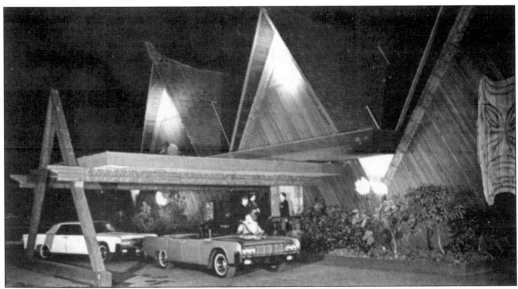

The Polynesia Restaurant on Pier 51, with its lush tiki interior and triple-A-frame exterior, cost $500,000 when it was built in 1961. Twenty years later, the state condemned it to expand the ferry terminal at Colman Dock. The building was put on a barge and moved to the Duwamish River. It was later burned for practice by the Seattle Fire Department. (Author's collection.)

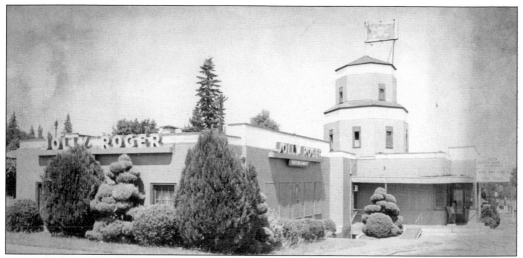

The Jolly Roger roadhouse opened in 1929 on Eighty-fifth Street and Bothell (now Lake City) Way, just outside the old city limits. During its early years as a Prohibition restaurant/speakeasy/brothel, the lookout tower notified everyone of arriving law enforcement. Duly warned drinkers snuck out a tunnel beneath the street. It later operated as a rock and blues bar, until an arsonist torched it in 1989. (Shoreline Historical Museum.)

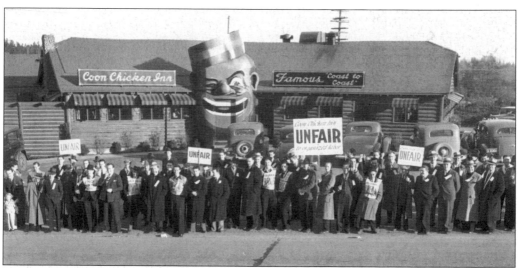

The Coon Chicken Inn, pictured here during a labor dispute, was part of a Utah-based chain. Open from 1929 to 1955 across the street from the Jolly Roger, it was as well known for its stereotype mascot (later depicted in the film *Ghost World*) as for its food. Succumbing to changes in both business and social climates, its owners replaced it with a burger stand, still open today as Ying's Chinese Drive-In. (MOHAI, *Post-Intelligencer* collection, No. PI-24093.)

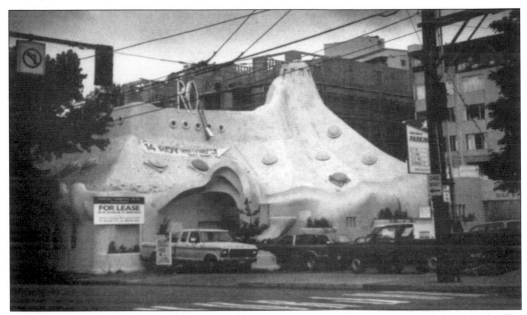

"The Blob" was developer Anthony Dudvar's 1984 attempt at an instant roadside landmark. The stucco structure in lower Queen Anne, with its odd curves and crannies, housed a succession of short-lived Greek and Mexican restaurants. It was demolished in November 1997. Some observers noticed a design similarity to the much fancier Experience Music Project, opened nearby in June 2000. (George Vernon collection.)

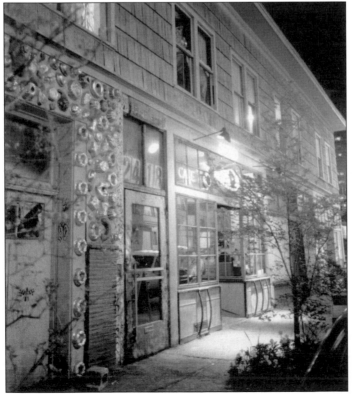

In 1984, an artists' housing collective, the Subterranean Cooperative of Urban Dreamers, leased the Sound View Apartments on Western Avenue. Until its demolition 12 years later, the building was famous for Diane Sukovathy's wall of Jell-O molds and for the Cyclops restaurant on its ground floor. A new Cyclops operates nearby at First Avenue and Wall Street. (Cam Garrett collection.)

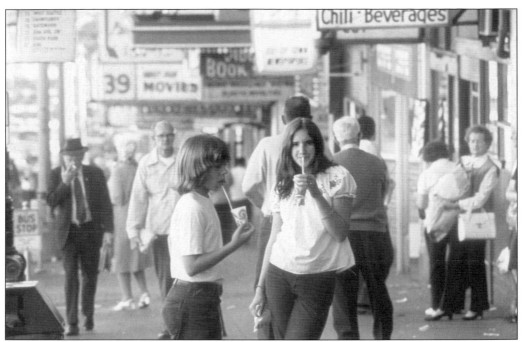

As downtown Seattle grew north from Pioneer Square in the early 20th century, Second Avenue emerged as its poshest shopping and banking street. First Avenue became the "sleaze district," brimming with inexpensive eateries and taverns catering to longshoremen and sailors. There were also tattoo parlors, pawn shops, risqué "novelty" stores, streetwalkers, and amusement arcades that eventually switched from sideshow games and pinball machines to peep-show booths. By the early 1970s, adult theaters joined this mix. The Pike Place Market's renovation helped spur an upscaling trend on First Avenue that has continued to the present day, having replaced almost all the old sleaze. (Above, *Pike Place Market News;* below, Seattle Municipal Archives.)

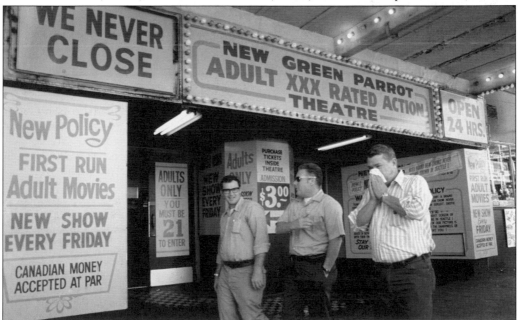

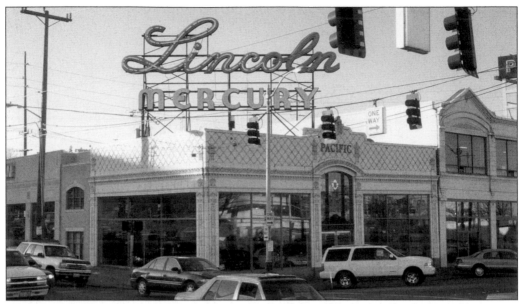

William O. McKay Ford and its Pacific Lincoln-Mercury affiliate had been Westlake Avenue staples since the Model A days. This elegant neon sign pleasantly distracted "Mercer mess" traffic-jam victims for decades, until a Land Rover dealership moved into the terra-cotta building. (Author's collection.)

When natural-gas pipelines reached Seattle in the 1950s, the Washington Gas Company closed its coal-burning gas plant on Lake Union (now Gas Works Park) and became Washington Natural Gas Company. This 26-foot-tall "blue flame" sign stood atop its Westlake-area office building until it merged into the Bellevue-based Puget Sound Energy. (Author's collection.)

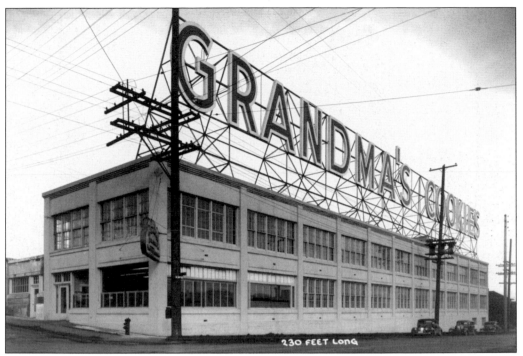

The Grandma's Cookies sign, 230 feet long and 30 feet tall, first shone its red neon glow onto the shores of north Lake Union in the 1940s. The company moved out of the building in 1970 when it consolidated production in Oregon, and the sign came down in 1978. (MOHAI, PEMCO Webster and Stevens collection, No. 1983.10.16428.)

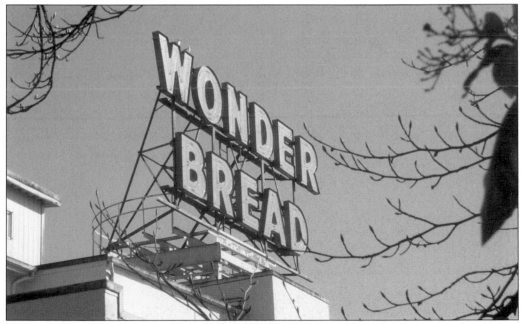

Since 1924, the Central Area's Wonder Bread sign has drawn motorists toward Seattle's least "white-bread" neighborhood. The bakery closed in 2000. The sign still stands atop the shuttered building for now; its future is still in dispute. (Author's collection.)

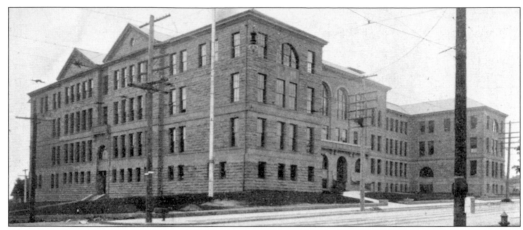

The original Seattle High School, built in 1902, was renamed Broadway High in 1909. In 1942, it lost a quarter of its students to the Japanese-American internment. In 1946, it was rechristened Edison Technical School, precursor to today's Seattle Central Community College. The stoic main building was razed in 1974; an auditorium annex survives as SCCC's Broadway Performance Hall. (Seattle Public Library.)

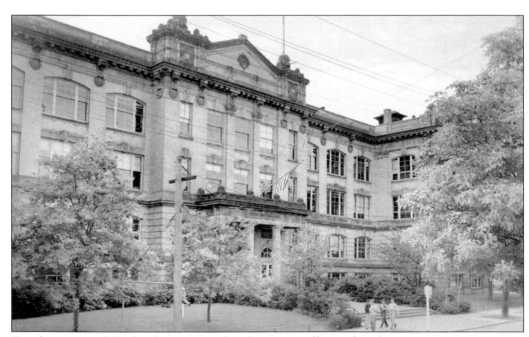

Two former Seattle high schools, both closed in 1981, still exist for other purposes. Queen Anne High (above) was refitted for apartments and later converted to condominiums. The Seattle School District kept Lincoln High in Wallingford to house students displaced by renovation projects in other school buildings. (Seattle Municipal Archives.)

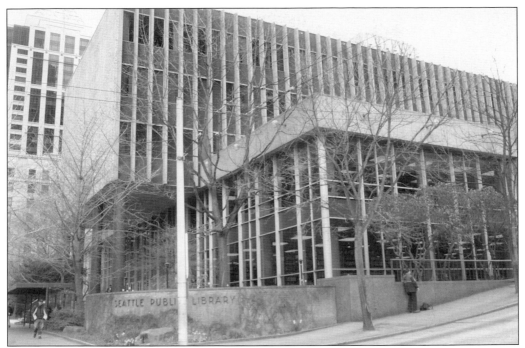

The Seattle Public Library first moved to Fourth Avenue and Madison Street in 1906, in a 55,000-square-foot beaux-arts stone edifice. That was replaced by this modern 206,000-square-foot building, opened in 1960. It closed in 2001; today's spectacular 362,987-square-foot Central Library opened three years later. (Author's collection.)

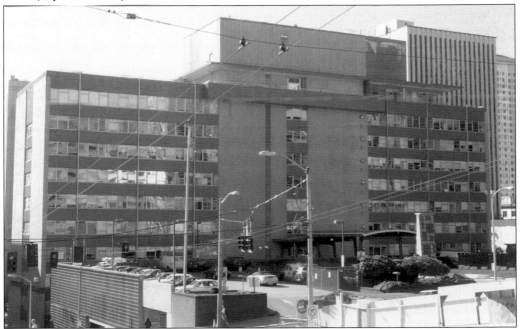

Seattle had a succession of city halls, including one shared with King County, when this plain but efficient Municipal Building was built in 1961–1962 for a mere $7 million. It was replaced in 2003 with a slicker but smaller $76 million structure. (Author's collection.)

First Christian Church was first organized in 1882, opening this building on Broadway in 1923. Damaged in the 2001 earthquake, it was razed in 2005. The site is now a parking lot. The congregation merged with Pilgrim Congregational to become All Pilgrims Christian Church. (Author's collection.)

Temple de Hirsch, Seattle's first Jewish Reform congregation, was started in 1899 and named after British Jewish philanthropist Baron de Hirsch. A new synagogue was built in 1960. It merged with a Bellevue group in 1971 to become Temple de Hirsch Sinai. The original 1908 building was razed in the early 1990s. (UW Special Collections, Todd 25023a.)

The three attached structures of the White-Henry-Stuart Building were built from 1908 to 1915 on the University of Washington-owned Metropolitan Tract. The 11-story Fourth Avenue edifice was one of Seattle's most prestigious office addresses, until it was bulldozed in 1974–1975 for the Rainier Bank Tower (now Rainier Square). (Author's collection.)

From 1889 to 1971, the ornate Burke Building at Second Avenue and Marion Street stood as a brick-and-stone monument to a city determined to prove its permanence. (It had been one of the first major buildings constructed after the Great Seattle Fire.) It was replaced by the Henry M. Jackson Federal Building. (Mary Randlett collection.)

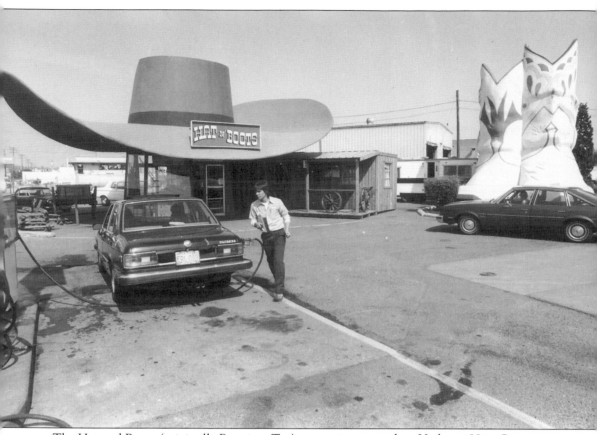

The Hat and Boots (originally Premium Tex) gas station opened on Highway 99 in Georgetown in 1954. Designed by Lewis Nasmyth and engineered by Bruce Olsen, it was intended as part of a Western-themed shopping center that was never finished. The hat (whose brim measured 40 feet across) contained the station's office; the male and female boots (22 feet tall) each contained a restroom. A commercial smash in its early years, the station later floundered after Interstate 5 became the chief Seattle–Tacoma motorway. After its 1988 closure, the structures deteriorated, and neighborhood activists pushed for years to have the Hat and Boots restored. In 2002, the State of Washington, which owned the land on which the structures sat, sold them to the Georgetown Community Council for $1. The hat's concrete brim, which had been used often by skateboarders, was deemed too damaged. The boots, and the hat's steel frame, were moved four blocks to Oxbow Park in December 2003. Work on their full restoration continues. (Pete Kuhns collection.)

Five

TRANSPORTATION

Getting around has always been a major issue here in the farthest corner of the 48 contiguous states. Every new way of moving has wrought changes in the city's social and economic landscape.

Seattle's early civic leaders waged long hard battles to bring major railroads here, instead of the Northern Pacific's "company town" of Tacoma.

Denny Hill was torn down because, in 1909, officials thought a flat neighborhood would be easier for horse-drawn vehicles to traverse.

The first airplane seen in Seattle was a barnstorming tourist attraction in 1910. In 1916, William Boeing opened a small factory to make his own aircraft. Within a quarter century, Boeing became the region's principal employer and main economic force.

Joshua Green's "mosquito fleet" steamships transported passengers and freight between Puget Sound's cities and towns before reliable roads were built. The gradual opening of the Pacific Coast Highway (later known in Washington as Highway 99) brought an end to both the Mosquito Fleet and to the Interurban Railway.

When ferryboats were the chief mode of transport across Lake Washington, Kirkland was the eastside's dominant town. With the arrival of the first bridge across the lake, Kirkland's prominence was overtaken by Bellevue.

The Northgate mall changed the way a nation shops and increased its reliance upon the automobile to accomplish simple, everyday, household tasks.

Interstate 5 divided downtown Seattle from its original bedroom communities of Capitol and First Hills. It also turned Aurora Avenue, north Seattle's segment of Highway 99, into less of a through-traffic artery and more of a shopping street.

In the late 1960s, voters approved improvements to bus service in King County but rejected a rail transit plan. A regional light rail system finally began construction in 2003. A separate, Seattle-only monorail plan was approved by city voters four times before it was finally scrubbed.

In 2006, Mayor Greg Nickels said he'd like Seattle's population to grow from 575,000 to 1 million. Somebody had better figure out how all those people are going to get anywhere.

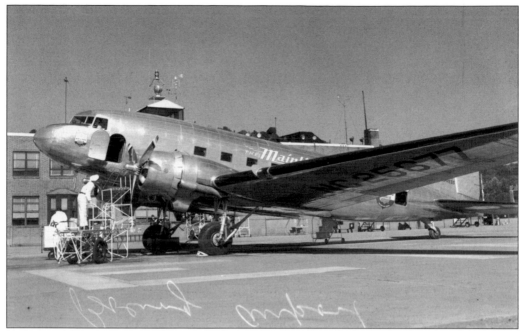

Boeing Field, Seattle's first major civilian airport, opened in 1928, and it is still heavily used for cargo, charters, and private flights. Here a Douglas plane is used by United Airlines (a former Boeing subsidiary) for its "Mainliner" service to Chicago and New York. (MOHAI, *Post-Intelligencer* collection, No. PI20289.)

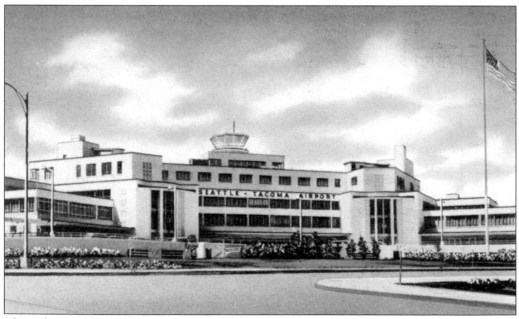

The military took over Boeing Field in World War II. A new passenger airport, Seattle-Tacoma (Sea-Tac) first opened in 1944. This terminal was officially dedicated in 1949. It has since been expanded and altered to the point of not being recognizable. (Author's collection.)

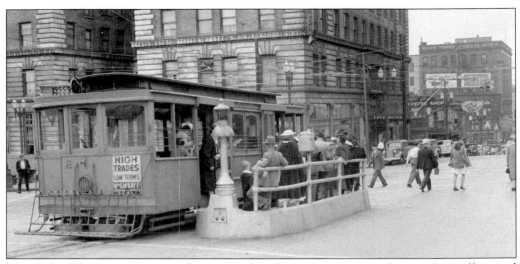

The Yesler Way streetcar is seen here on its last day in August 1940. Since 1884, trolleys and cable cars (first horse-drawn, then electrified) had connected Seattle's downtown streets and outlying neighborhoods. The tracks were later dug up during a World War II scrap-metal drive. (Seattle Municipal Archives.)

From 1902 to 1928, the Interurban Railway provided fast, frequent electric-train service from Seattle south to Tacoma. Another line ran north to Everett from 1910 to 1939. Much of the old right-of-way is now the Interurban Trail. Richard Beyer's 1978 public sculpture in Fremont, *Waiting for the Interurban*, commemorates the line. (Seattle Municipal Archives.)

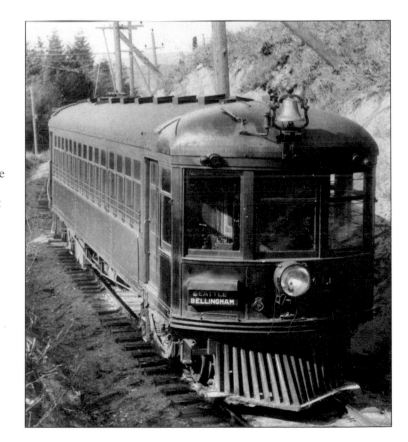

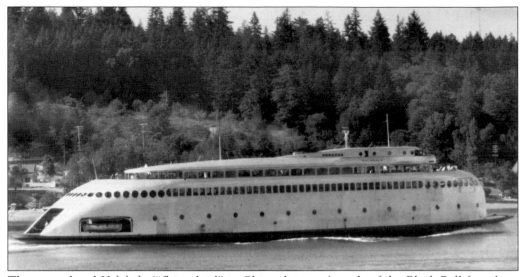

The streamlined *Kalakala* ("flying bird" in Chinook jargon), pride of the Black Ball ferry line, was built in 1937. It was the largest, fastest, and fanciest passenger boat on Puget Sound. It was sold in 1967 and became a fish processor in Alaska. Seattle artist Peter Bevis launched a drive to bring the *Kalakala* home, which he did in 1998. It is now docked in Tacoma, awaiting restoration. (S. J. Pickens collection.)

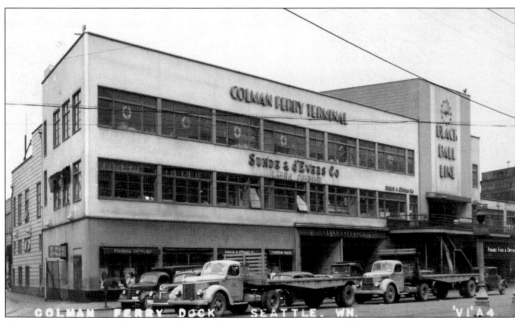

To complement the *Kalakala*, Black Ball replaced the ornate Edwardian terminal building at Colman Dock with this modernistic edifice. In 1961, the now state-owned ferry system replaced it with a larger and sturdier, if less elegant, structure. (S. J. Pickens collection.)

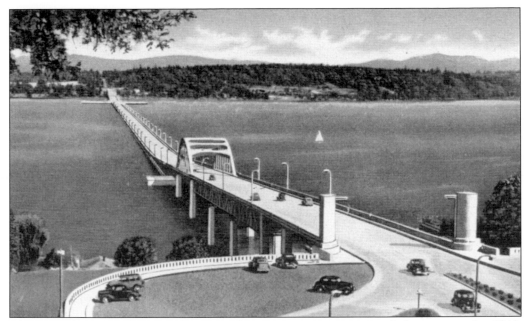

The original Lake Washington Floating Bridge was an engineering marvel when it opened in 1940. It was later renamed after state transportation planner Lacey V. Murrow, brother of newscaster Edward R. Murrow. The bridge opened the east side of Lake Washington to suburban sprawl, which overwhelmed its capacity. A parallel bridge was added in 1989; the original was under reconstruction when a 1990 windstorm sank it. (Author's collection.)

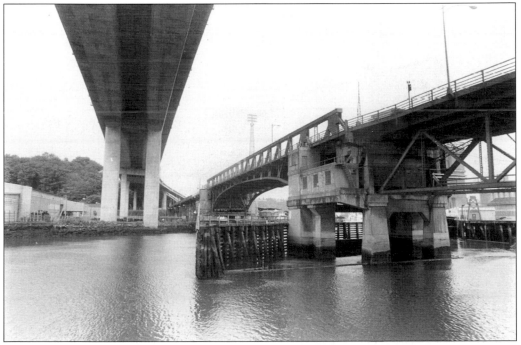

The first West Seattle bridge, built in 1924, was permanently damaged in 1978 when freighter captain Rolf Neslund rammed into it. The crash sped up long-stalled plans for a new bridge (seen to the left), which opened in 1984. (Pete Kuhns collection.)

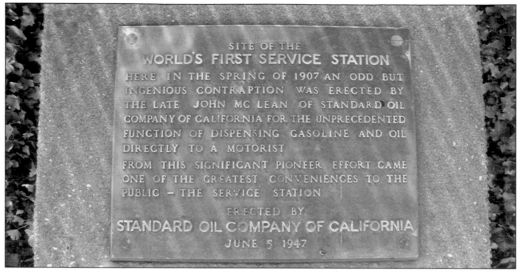

In the automobile's infancy, motorists bought gasoline in big metal barrels. Then a depot supervisor for Standard of California (later Chevron) devised a primitive pump-and-hose system, creating the first gas station. (Gulf Oil also claimed to have started the first gas station, until Chevron bought Gulf.) This 1947 plaque stands at 2715 East Marginal Way South. (Seattle Municipal Archives.)

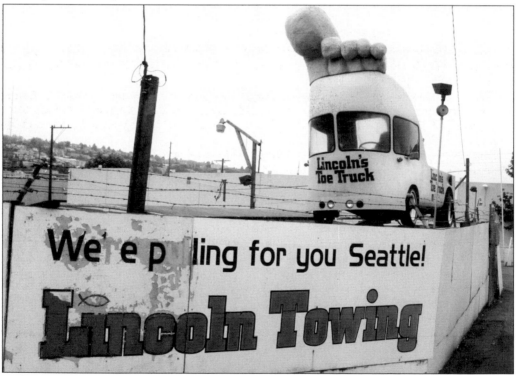

Seeking a happier image for an industry known for giving bad news, Lincoln Towing commissioned its first custom "Toe Truck" in 1980. A second, "right foot" truck was added in 1996. The first truck is now on display at MOHAI and the "right foot" one now stands at the Aurora yard of RoadOne, which bought Lincoln in 2000. (Author's collection.)

Six

PRODUCTS
AND COMPANIES

As a major hub for sea and air shipping, Seattle's business promoters have always extolled the virtues of the global economy. Yet parts of the local economy did better when things were less global.

There was a time before the same big-box chain stores dotted every suburb in America. A time before every aspect of commerce was consolidated, right-sourced, or downsized. A time when local producers could sell local products in local stores, with the backing of local banks and the help of local ad agencies.

This was when Rainier was the largest-selling beer in the Puget Sound region, while archrival Olympia was No. 1 in the rest of the state. Fisher and Centennial mills filled the region's flour bins. Langendorf and Sunbeam breads were topped with Sunny Jim peanut butter. Gai's buns were filled with Bar-S hot dogs, topped with Nalley's relish, and served with a side of PictSweet vegetables.

Some brands, like Nalley's, are still made here but are owned by out-of-state giants. Others, like Marie's salad dressings, are neither made nor owned here anymore.

Other firms, born and nurtured here, moved their headquarters to points east and south—United Parcel Service (to Atlanta), Carnation (to Los Angeles), even Boeing (to Chicago). And some, like commercial-music provider Muzak, started someplace else, moved their head offices here for a while, then moved on to yet another place.

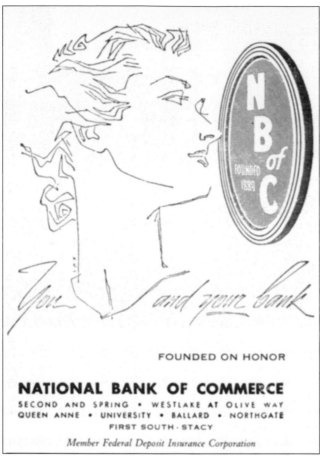

National Bank of Commerce of Seattle (NB of C), founded in 1889, was the strong second player in Seattle's banking world. In 1974, while building a downtown tower to rival Seafirst's, NB of C changed its name to Rainier Bank. In 1988, Rainier sold out to California's Security Pacific Bank, which soon afterward sold out to Bank of America. Some former Rainier branches were sold to Idaho's WestOne Bank, which merged into U.S. Bank. (From *Argus Annual*, Pacific Publishing.)

FOUNDED ON HONOR

NATIONAL BANK OF COMMERCE

SECOND AND SPRING • WESTLAKE AT OLIVE WAY
QUEEN ANNE • UNIVERSITY • BALLARD • NORTHGATE
FIRST SOUTH - STACY

Member Federal Deposit Insurance Corporation

Seattle-First National Bank (Seafirst) was born in the Depression-era merger of three smaller banks. (One was the Dexter Horton National Bank, started in 1870 by a pioneer storekeeper.) Seafirst was the region's biggest bank until the early 1980s, when management invested heavily in shaky oil deals with Oklahoma's Penn Square Bank. Penn Square's collapse led a weakened Seafirst into a buyout by Bank of America. (Author's collection.)

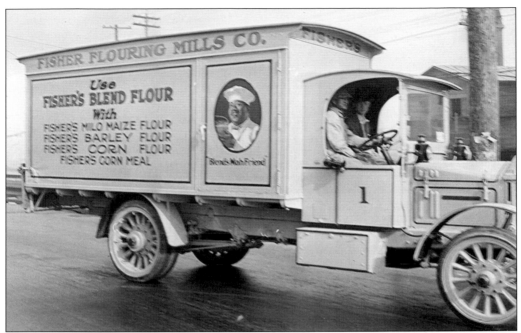

The Fisher Flouring Mill on Harbor Island opened in 1911 (less than two years after the man-made island was built from Denny Regrade dirt). It was the home of Fisher's Blend Flour (once advertised with the caricature of a black chef proclaiming, "Blend's Mah Friend"), Puyallup Fair scone mix, Zoom hot cereal, and many other products. The Fisher family's empire grew to include office buildings and broadcasting stations (including KOMO radio and TV). Pendleton Flour Mills bought the plant in 2001 and closed it a year later. King County plans to redevelop the site for a solid-waste transport facility. (Seattle Municipal Archives.)

The Imperial Candy Company introduced Societé hard candies and mints in 1906. Over the years, its packaging evolved from wooden buckets (for bulk sales in general stores) to collectible metal tins, then to simple cellophane bags and cardboard boxes. Societé's Western Avenue factory, near the central waterfront, was demolished in 1974 (the site is now a parking lot); production continued in suburban Bellevue for a few more years. (Advertisement from *Argus Annual*, Pacific Publishing.)

keep

Societe

candy handy

Be prepared . . . for unexpected holiday friends and a happy family . . . have plenty of Societe Candy handy! Let your sweet tooth make a selection from the wondrous Societe varieties . . . cello-wrapped for freshness and in convenient boxes!

Made Fresh!
Packed Fresh! Sold Fresh!

Since 1906

Germanus Wilhelm Firnstahl bought his first peanut roaster in 1921, making peanut butter that he sold in the Pike Place Market. He devised the "Sunny Jim" mascot after his son Lowell, who had died at age 19. At its peak under Firnstahl's daughter Celeste Rogge, Sunny Jim sold peanut butter, roasted peanuts, jams, jellies, pancake syrup, and soft drinks throughout the West. The family sold the company in 1979; it closed a decade later. Its Airport Way factory was destroyed by fire in 1997. (Seattle Public Library.)

Mary Pang, sister of restaurateur-politician Ruby Chow, and her husband, Harry, had produced frozen entrees and side dishes since the early 1970s. On January 5, 1995, a vicious nighttime blaze struck the plant on Seventh Avenue South. Four Seattle firefighters died, and a memorial statue for them now stands in Occidental Park. Pang's son Martin confessed to setting the blaze for insurance money. (Author's collection.)

The Pommerelle Company started making inexpensive screw-top wines in Seattle in 1934, just after the end of Prohibition, and it thrived under Washington state laws that restricted California imports. As those laws changed in the late 1960s, Pommerelle expanded into higher-quality wines under the Ste. Michelle name. Now based in suburban Woodinville, Ste. Michelle Wine Estates claims to be America's sixth largest premium wine producer. (Seattle Public Library.)

undoubtedly one of the world's great wines

WINEMASTER

two exceptional varieties— grenache – rosé and pale dry cocktail sherry.

coming soon: dry semillon.

THE POMMERELLE COMPANY • SEATTLE, WASHINGTON

Edwin Teel opened the Vitamilk Dairy in the late 1930s. Teel (later succeeded by his son Jerry) built his business on "handshake agreements" with area farmers. Its main plant was an industrial anomaly in an otherwise residential Green Lake neighborhood. In 2003, the Teels closed the plant, sold their other assets to Wilcox Dairies, and made plans to redevelop the Vitamilk site for luxury homes. (Author's collection.)

PORK WITH JUST THE RIGHT BLEND OF BEEF

Charles Frye (1858–1940) opened his first meatpacking plant in South Seattle in 1888. In 1950, Walter Greathouse, company president and trustee of the Frye estate, sold its assets to rival Seattle Packing Company. The proceeds helped fulfill a request in the Frye will to establish a free art museum in Seattle, which Greathouse and his wife, Kay, managed for more than four decades. (Seattle Public Library.)

The Seattle Packing Company began in 1940 as a wholesaler and added processing after World War II. A few years after buying Frye and Company, it consolidated its products under the name Bar-S ("Best in the West, Bar None"). It was the exclusive meat supplier to the 1962 Seattle World's Fair. The Arizona-based Cudahy Company bought Bar-S in the late 1960s; the Seattle plant remained until the mid-1980s. (Seattle Public Library.)

Leopold Schmidt had already run successful breweries in Montana and Oregon when he bought some artesian wells and adjacent land in the Olympia suburb of Tumwater. Olympia Beer, with the slogan "It's the Water," debuted in 1896 and became a favorite throughout the West. (During Prohibition, the Schmidt family started the Western (now Westin) hotel chain.) By the 1960s, "Oly" used solid, if square, "outdoorsy" marketing to become the Northwest's biggest brand (though it trailed Rainier in Seattle-area sales). A disastrous "hip" ad campaign in 1983 led the Schmidts to sell out to Pabst. In 1999, Pabst, deciding to specialize in marketing, sold the Tumwater plant to Miller, which mostly used it to make Pabst-owned brands under contract. Miller shuttered it in 2003, ending 125 years of mass-market beer production in Washington. (Both Jules Maes Saloon collection, Georgetown.)

Andrew Hemrich opened the Bay View Brewery in South Seattle in 1878. It merged with two larger firms in 1893 to form the Seattle Brewing and Malting Company, whose flagship brand was Rainier Beer. Rainier became Seattle's most popular beer and was shipped as far as Alaska. Its Georgetown main plant was the world's sixth largest brewery by 1916, when Prohibition shut it down. Upon repeal, Canadian Fritz Sick and his Tacoma-born son Emil bought Rainier's old Airport Way plant, then acquired the Rainier name from a California firm that had picked it up. Emil Sick later topped the brewery with a neon version of Rainier's red "R" logo, designed in 1949 by New York advertising agency Walter Landor and Associates. Attractive packaging and aggressive marketing helped "Mountain Fresh" Rainier stay Seattle's favorite beer through the 1950s. (Both Jules Maes Saloon collection.)

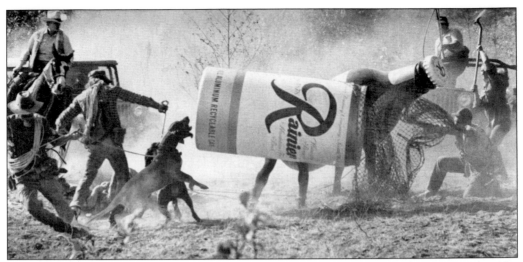

After Emil Sick's 1964 death, Canada's Molson bought Rainier. In 1974, local adman Terry Heckler (who also designed the Starbucks logo) began a hip, funny marketing campaign, featuring such popular motifs as "the wild Rainiers." By Rainier's 1978 "Beercentennial," its production soared to a million barrels per year. (Seattle Public Library.)

Heilman Brewing bought Rainier in 1977, amid increasing competition from the "majors." In 1987, Australian financier Alan Bond bought Heilman. Bond replaced Heckler's Rainier advertisements with a more conventional campaign by a California agency. Sales plummeted. In 1999, Stroh's, which bought Heilman from Bond, closed Rainier and sold its brands to Pabst. Tully's Coffee and an artist-housing project now occupy the site; this "Lady Rainier" statue is to be moved to Oxbow Park near the Hat and Boots. (Author's collection.)

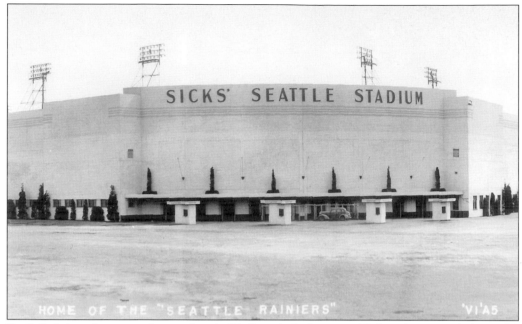

Emil Sick bought minor league baseball's Seattle Indians in 1937 and renamed them the Rainiers. The next year he moved them into his own Sicks' Seattle Stadium in the south end, where they played until 1968. (It was demolished in 1977; a Lowe's home center occupies the site.) Cartoonist Bob Hale (see page 122) adapted the red "R" logo into a Rainiers team mascot. (Dave Eskenazi collection.)

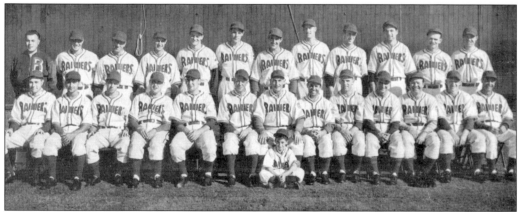

When this 1942 Rainiers photograph was taken, the team had been Pacific Coast League champions the previous three years. Wartime player shortages would halt that string of titles. In the bottom row, fifth from left, is Dewey Soriano, future son-in-law of *Post-Intelligencer* sports editor Royal Brougham. Soriano later owned the major-league Seattle Pilots, who played one season (1969) in Sicks' Seattle Stadium, then moved to Milwaukee. (Dave Eskenazi collection.)

Seven

SPORTS, ARTS, AND ENTERTAINMENT

Basketball's Supersonics introduced Seattle to major professional sports. Other teams would take a while to arrive and to catch on.

After the Pilots' one-season debacle, local politicians sued the American League and won a new baseball franchise. The league, however, demanded a new stadium with a roof. (They seemed to think it rained a lot here.) The King County Multipurpose Domed Stadium (Kingdome) became a topic of controversy before, during, and after its 24-year existence. But it brought baseball (the Mariners) and professional football (the Seahawks) to Seattle, alongside the Sonics.

Each of these three teams would have its ups and downs, in both popularity and league standings; and each would threaten to leave town at least once. (The Sonics, in 2006, were the most recent team to make this threat.)

Other teams have come and gone, including the Sounders (of the North American Soccer League), the Sea-Port Cascades (World Team Tennis), the Reign (American Basketball League), the Totems (Western Hockey League), and two indoor soccer teams.

Spectator sports, of course, were never the only targets for Seattleites' leisure dollars. The nationwide Pantages and Considine vaudeville circuits started here. Seattle had what some claim was America's first movie palace. The once-small live theater scene exploded in the 1960s and 1970s, only to contract in the 1990s as funding tightened up. Seattle has also had a symphony and chamber music groups since before World War I. The years after the world's fair saw acclaimed opera and ballet companies join that mix. Seattle has become a recognized center for modern dance, performance art, and independent film and video. There are now spectacular art museums and a thriving group of commercial galleries.

But entertainment and the arts are volatile milieu, subject to massive changes in public tastes and funding support.

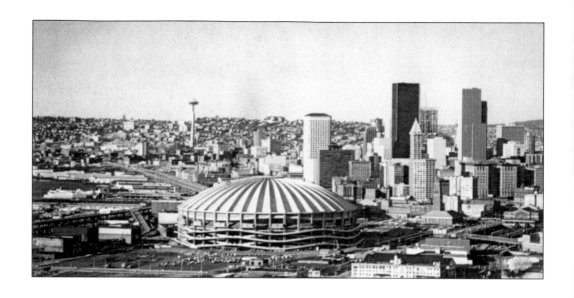

The Kingdome, built south of Pioneer Square on filled-in tide flats, cost $40 million. This money bought an efficient yet very plain concrete structure. Its first sports event was a Sounders soccer match in April 1976. The Seahawks debuted that August; the Mariners followed the next April. The Supersonics played seven seasons in the Dome, including their 1978–1979 championship season. College basketball's Final Four came to the Dome three times. While the Dome's utilitarian look and noisy acoustics made it great for football, baseball fans hated it. The Mariners' and Seahawks' owners demanded separate, fancier homes with luxury boxes. After four ceiling tiles fell into unoccupied seats before a scheduled 1994 Mariners game, the Dome was doomed. It was imploded on March 26, 2000. (Above, author's collection; below, Seattle Municipal Archives.)

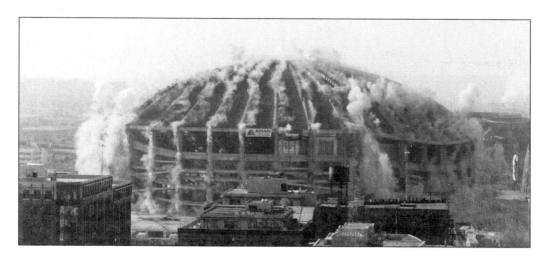

In March 1933, after more than a decade of lobbying, Seattle businessman Joseph Gottstein convinced Washington's legislature to allow horse racing with pari-mutuel betting. That August, Gottstein and his partners opened Longacres on a former Renton dairy farm. The track and grandstands had been built in just 28 days. In 1935, Gottstein added the track's signature event, the annual Longacres Mile, with a then-huge $10,000 added purse. Triple Crown winner Seattle Slew (bred in Kentucky but with local owners) made a non-racing "golden gallop" at the track in 1977. Gottstein's heirs, led by son-in-law Morrie Alhadeff, sold the land to Boeing in 1990 for offices. The track closed in 1992. (It had been the west's oldest continually operating racetrack.) Its replacement, Emerald Downs in Auburn, did not open until 1996. The Longacres Mile continues as Emerald Downs's biggest annual draw. (MOHAI, No. 1991.1.144.1.)

Seafair's hydroplane races have drawn crowds to Lake Washington since 1950. In the pre-Mariners years, they were Seattle's biggest summer attraction. Today's thunderboats are turbine powered, but many fans dearly remember the roar of the old "piston" boats with surplus World War II aircraft engines. (David Williams/Hydroplane and Raceboat Museum.)

While *Miss Budweiser* was the most famous hydroplane operation, local sponsors played a huge role in supporting the sport. These included Sunny Jim foods and the Pay 'n Pak hardware chain. (David Williams/Hydroplane and Raceboat Museum.)

Greenwood's Leilani Lanes opened in 1961 at the peak of Hawaii-mania. It featured tiki carvings at its entrance and contained a kitsch-fabulous "Lani Kai Lounge." It closed in March 2006 for redevelopment, as have many area bowling palaces. (Bellevue's Belle Lanes became a Barnes and Noble bookstore.) (Author's collection.)

The 211 Club, Seattle's serious pool hall, was named for its original address on Union Street. (It was the main setting for the film *House of Games*.) In 1987, it moved to Belltown, in the building where the Speakeasy Cafe later opened. Rising rents forced the 211's closure in December 2000, saving most of its vintage pool tables from the fire that engulfed the building five months later (see page 43). (Author's collection.)

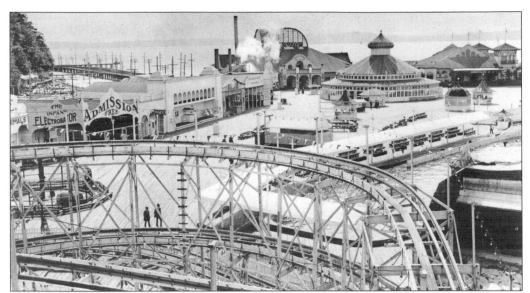

Luna Park was billed as "Seattle's Coney Island of the West" upon its 1907 opening. Built on a pier over Alki Point tide flats, it offered fresh and saltwater swimming pools, a dance hall, amusement rides, and the city's best-stocked bar. But forces of moralism, spurred by scandalous newspaper reports of underage drinking and intergenerational dancing, forced its closure by 1913. (UW Special Collections.)

Seventeen years after Luna Park's demise came another private amusement park. Playland opened in May 1930 on North 130th Street, beyond the old city limits. It was accessible by Interurban train and later by the new Aurora Avenue highway. (Seattle Municipal Archives.)

Among Playland's attractions over the years were a "Mystery House" (above) and a racetrack used mostly by "midget" cars. Other entertainments included an 85-foot-tall wooden roller coaster, a carousel, a penny arcade, and a miniature railroad. In 1954, the City of Seattle annexed the park, which had been in unincorporated King County. Faced with the prospect of rebuilding everything to the city's more stringent fire codes, owner Carl Phare chose not to contest the city's 1960 condemnation of his land. The park closed in September 1961; the World's Fair Gayway (now the Seattle Center Fun Forest) opened the next spring. Playland's racetrack and parking lot became a Gov-Mart store (now a strip mall anchored by Rite Aid), and the main grounds became a junior high school and city park. (Shoreline Historical Museum.)

Woodland Park Zoo has come a long way since its 1889 start as a privately owned menagerie. Larger, more "natural" animal habitats have replaced earlier, more entertainment-oriented attractions. In a 1960 fundraiser, "elephant keys" were sold for 50¢. They activated 45 "Talking Storybooks" throughout the zoo, which played brief audio lectures about the different creatures. (Julie Albright collection.)

Pres. Warren G. Harding spoke in Seattle on July 27, 1923, stating recent reports of big oil reserves in Alaska "sound more fabulous than real." It was his last speech—he died in San Francisco six days later. In 1925, a Harding memorial was built in Woodland Park, where he'd spent part of his visit. It was demolished in the late 1970s. (UW Special Collections, Hamilton 2987.)

In Seattle, as in other cities, artist live-work spaces preserved many handsome old buildings, only to later be forced to move so the buildings could be used for more lucrative purposes. Among the best remembered places for paintings and parties: the Washington Shoe Building (above) in Pioneer Square (now offices) and 66 Bell in Belltown (now condos). (Author's collection.)

Linda Farris (1944–2005) was among Seattle's top contemporary art promoters. She opened her namesake gallery in Bellevue in 1970, moving it to Pioneer Square in 1971. It spurred several local artists' careers (including Dennis Evans, Norie Sato, Marsha Burns, Randy Hayes, and Ginny Ruffner). After closing the gallery (this plaque now adorns the front wall), she founded the Contemporary Art Project, which acquired works by young artists and donated them to the Seattle Art Museum. (Author's collection.)

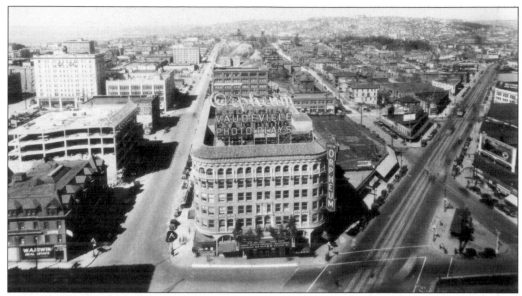

The Seattle Orpheum began as a vaudeville house and moved seamlessly into the era of talking pictures. In this 1932 photograph, still-unfinished sections of the Denny Regrade are in the distance. The Orpheum lasted long enough to be visible from the 1962 Seattle World's Fair monorail. It was razed in 1969 for the Washington Plaza Hotel (now the south tower of the Seattle Westin). (Seattle Municipal Archives.)

Seattle's Paramount, Moore, and Fifth Avenue theaters were saved for stage shows, but the Music Hall (also known at various times as the Fox, the Seattle Seventh Avenue, and the Emerald Palace) was one glorious movie house that did not survive, despite being used in the 1970s as a supper club with a clean Vegas-style revue. The Music Hall was razed in 1991; nothing was built on the site until 1999. (UW Special Collections, No. UW 18649.)

The Coliseum Theater, designed by legendary architect B. Marcus Priteca, opened in January 1916. Some historians recognize it as the first building in America built expressly to show motion pictures. The luxurious movie palace became a decrepit dowager by the 1970s, finally closing in 1990. Four years later, with federal historic preservation tax credits, it was remodeled into a Banana Republic clothing store. (UW Special Collections, Hamilton 3043.)

The Broadway, a small but handsome neighborhood cinema, advertises *Sitting Pretty* (1948), the debut of future sitcom character "Mr. Belvedere." Despite uproars from neighborhood advocates, it closed in 1989 to become a Pay 'n Save (now Rite Aid) drugstore. The new occupants kept the marquee and installed movie-nostalgia murals inside. Pictured near the pharmacy counter was tragic prescription abuser Marilyn Monroe. (UW Special Collections, No. UW 23645.)

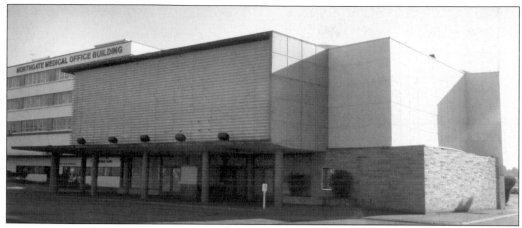

Northgate, America's first true shopping mall, opened in 1950 with America's first shopping-mall cinema. Besides movies, the huge Northgate Theater also provided a stage for community meetings and theatrical productions. As single-screen cinemas became commercially passé, the Northgate hosted rock concerts before its 2006 demolition. (Seattle Municipal Archives.)

The United Artists 70/150 was Seattle's first twin cinema. It was named after two 1950s widescreen fads—70mm and Dimension 150. Its biggest draw was the original *Star Wars* in 1977. It later operated as a second-run discount house before it closed in 1998. When it was razed four years later, crews stuck one last sign on its marquee: "DEMOLITION MAN." (UW Special Collections, Hamilton 71-76.)

B. F. Keith's Palace, a vaudeville-turned-movie house next to the Smith Tower, had become a strip joint by the mid-1970s. Owner Roger Forbes, who ran most of Seattle's adult cinemas, "restored" it in 1977 to host this risqué stage musical. In the 1980s, it housed the Pioneer Square Theater, whose punk-rock parody musical *Angry Housewives* ran for six and a half years. The building now houses an insurance office. (UW Special Collections, Hamilton 13-20.)

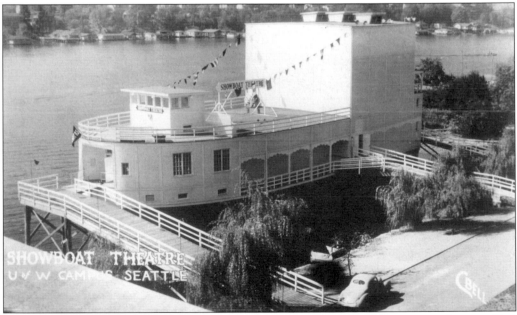

The University of Washington has kept most of its historic campus buildings up and active. One exception is the Showboat Theater, built in 1938 on a barge moored on Portage Bay with help from the federal Works Progress Administration. A ghost (said to be that of ex-UW drama head Glenn Hughes) supposedly haunted its backstage and dressing rooms. The Showboat was leveled in 1997. (Author's collection.)

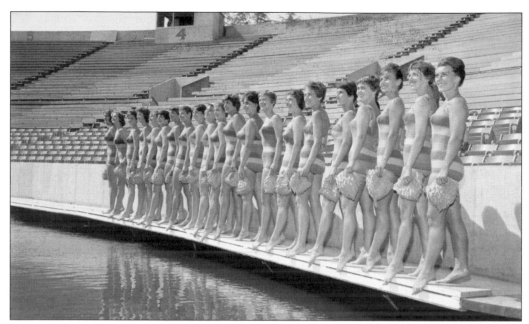

From 1950 to 1964, the Aqua Theater on Green Lake was home to the Aqua Follies, an annual swimming, diving, singing, and dancing spectacular. It also hosted dramatic productions and rock concerts through 1969. The site was rebuilt in the 1970s as a shell house, and only skeletal sections of the grandstand remain. (Brittany Wright collection.)

Ted Griffin owned a private aquarium on the Seattle waterfront when he bought one of the first captive "killer" whales, Namu, named for the Canadian town where he had been caught in a fishing net. Griffin built a floating pen to tow Namu to Seattle. Griffin and the whale performed together for 11 months, until Namu caught an infection and died in his pen. (UW Special Collections, Clifford B. Ellis collection.)

Eight

CENTURY 21 AND SEATTLE CENTER

Seattle's first big fair was the Alaska-Yukon-Pacific Exposition (AYP), held in 1909 at the University of Washington campus to celebrate the young city's connection to the North's gold and other resources. In the 1950s, local civic leaders proposed a new fair for 1959, to mark AYP's 50th anniversary. The international group that sanctions world's fairs awarded Seattle a 1962 date, allowing three extra years for planning and construction.

The Century 21 Exposition was intended to re-brand Seattle in both national and local eyes. Seattle wouldn't be seen as just a picturesque wilderness outpost but as the capital of jet air travel, a center for science and the arts, and a place where a brighter tomorrow was being planned for today.

Charles Herring, KING-TV's first news anchorman, said while covering the opening ceremony that the fair offered "a futuristic look into the future." The iconic Space Needle (developed by a private partnership called the Pentagram Corporation) inspired the "Sky City" setting of television's *The Jetsons*. The Science Arches symbolized the abstract beauty behind numbers and spatial relationships. In the World of Tomorrow exhibit in the Coliseum (later rebuilt as KeyArena), audiences passed multiscreen slide shows of contemporary social problems on their way toward a scale model of a 21st-century domed Seattle, where clean nuclear power and in-home computers (imagine that!) would help alleviate all concerns.

The fair drew high crowds, turned a profit, and achieved its goal of putting Seattle on the proverbial "map" in the arts (kick-starting the Seattle Opera and a professional theater scene), sports (Seattle's first major professional team, basketball's Supersonics, showed up in the Coliseum in 1967), and high tech (as Boeing's engineering prowess was later joined by medical technology, computer programming, and biotech). Seattle had become a place of thinkers, dreamers, and creators.

When the fair's six-month run ended, the grounds closed for a year and a half of alterations, before reopening as the city-owned Seattle Center.

In late 1999, as the fair's prophesied century neared, Mayor Paul Schell abruptly canceled plans for a New Year's spectacular. The reason was a plot by a lone terrorist to bomb the Space Needle, foreshadowing the tragedies on the East Coast less than two years later.

The place that once symbolized the future could, in the future, become a throwback to nostalgia for a rustic past. The Sonics were sold to Oklahoma buyers in 2006, leading some to wonder if the team (one of the center's chief revenue sources) will stay in town. Former *Seattle Weekly* publisher David Brewster has advocated razing KeyArena and many of the center's other buildings, in favor of an "urban wilderness" park.

The fairgrounds incorporated High School Memorial Stadium, built 14 years before on the site of the baseball park that Sicks' Seattle Stadium had replaced. The stadium housed the fair's opening and closing ceremonies, and a specially-dug circular pool hosted boat races and water-ski exhibitions. (UW Special Collections, No. UW 26499.)

The glass-enclosed Bubbleator took up to 150 fairgoers at a time to the World of Tomorrow exhibit in the Coliseum. (The sphere received a blue paint job along the bottom to prevent boys from looking up women's dresses.) After the fair, the Bubbleator moved to the Food Circus (now Center House) building until 1985. It is now a private greenhouse in a South Seattle backyard. (Deran Ludd collection.)

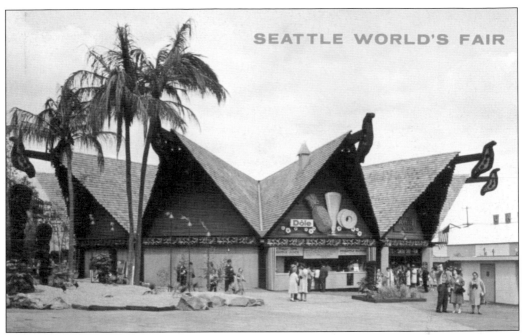

Some of the fair's "temporary" buildings were just that, razed or trucked away after October 1962. But some stuck around a while. The Hawaii exhibit building was moved to the Seattle Center Fun Forest, where it housed concessions and arcade games for more than 20 years. (TikiRoom.com.)

Along with the speculative science in the World of Tomorrow exhibit, the fair also housed factual science displays, at what is now the Pacific Science Center. Here a couple ponders a spacecraft cutaway complete with an authentic NASA spacesuit. (UW Special Collections, No. UW 24659.)

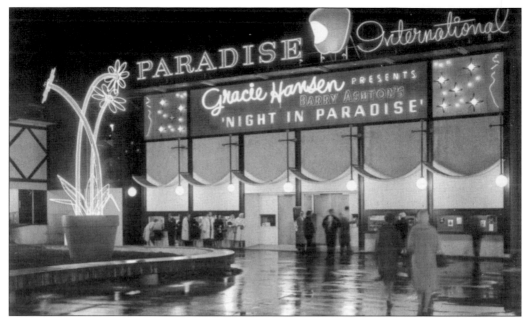

Gracie Hansen's Paradise International headlined Show Street, the fair's "adult entertainment" section. Hansen, a gracious grandmother from southwest Washington, was the perfect hostess and public relations woman for the "naughty but nice" girlie revue. Other Show Street attractions included an adult puppet show by future Saturday-morning television producers Sid and Marty Krofft. Show Street's site, vacant for decades after the fair, now houses the PBS affiliate KCTS-TV. (Deran Ludd collection.)

Several Century 21 buildings already existed before the fair. The Food Circus was an armory; the Arena was an ice rink; and the Opera House was the Civic Auditorium, which since 1927 had hosted everything from boxing matches to Frank Sinatra concerts. It has since been rebuilt a second time as McCaw Hall. (Seattle Center Archives.)

The "Union 76 Skyride" gave fairgoers a bird's-eye view of the grounds. Its gondolas and wires are now installed at the Western Washington Fair in Puyallup. The Skyride's signage was the debut of the "76 ball," the oil company's principal logo for the next four decades. (UW Special Collections, No. UW 26500.)

The amusement-ride area at the world's fair was called the "Gayway." In its Seattle Center incarnation, it was the Fun Forest, where generations of kids have swooped up, down, and all around. One of its top attractions, the Flight to Mars, was removed in the late 1990s to make room for Paul Allen's rock music museum, the Experience Music Project. (MOHAI, No. 1965.3598.23.8.)

Walter "Doc" Jones started his Jones Fantastic Museum in suburban Mountlake Terrace, then moved it into the Center House. It offered a fun, macabre collection of odd coin-op machines, mechanical robots, wax figures, horror-movie posters, and other attractions for deranged boys of all ages and genders. After Jones died in 1975, his heirs ran it for five years, then sold the contents to an Oregon collector. (Willum Pugmire collection.)

Jones occasionally hired human (or inhuman) attractions at his museum. One was the vampire character "Count Pugsly," played by Franklin High School student Willum Pugmire. He later became a punk-rock fanzine editor and horror fiction author. (Willum Pugmire collection.)

Nine

MEDIA PERSONALITIES

Local television and radio used to be a more freewheeling, more informal, and a more local business than it is now.

All of Seattle's television stations used to be locally owned, as were most of its radio stations. Even when a station had out-of-town owners, it still had strong local managers, who gave each station a clear "brand identity" and a community presence.

Local television newscasts were not able to relay live remotes from every house fire in town. They covered a few stories a day on film but also relied on reporters and anchors who could write great copy and deliver it with personality. They were punctuated by in-studio commentators, such as KIRO's amiable conservative Lloyd Cooney and KING's pugnacious liberal Don McGaffin.

And news wasn't all local stations did. They had local kids' shows, whose colorful hosts never missed a parade or a supermarket opening, and talk shows, which on any given day might feature the mayor, a poet, or a crafts demonstration.

The commercials, too, provided a steady parade of entertainers: Hippie-dippie car dealer Dick Balch flashed a "peace" sign, then slammed a sledgehammer into a fender. The square, bespectacled Glen Grant monotonically promised to "stand on my head to make you a deal." An ever-perky Sunny Cobe Cook, founder of Sleep Country USA, promised great mattress bargains "if you're not picky about color." Appliance dealer Jack Roberts flailed his arms and screeched "We won't be undersold," while his wife stood by unamused.

On the radio side, no local station would ever cede its drive-time shifts to syndicated "shock jocks." They all had local DJs, playing tunes carefully picked for local appeal. At times, they could "break" local musicians into the national spotlight and make them stars.

Chris Wedes was not a traditional clown. He didn't juggle or do tricks, and his humor relied more on ad-libbed wordplay than on miming. But he owned a city's collective young hearts. From 1958 to 1981, Wedes starred on KIRO-TV as children's entertainer extraordinaire Julius Pierpont Patches, known to all as "J. P." Set in a magic shack at the City Dump, J. P.'s was the first live show on KIRO's first day on the air. It remained a ratings winner for nearly a quarter century thanks to Wedes's sharp wit, anarchistic charm, and un-preachy rapport with young viewers. Before the FCC cracked down on commercial endorsements by kids' hosts, J. P.'s face adorned milk, bread, peanut butter, and hot dog packages throughout Puget Sound. Wedes still makes personal appearances as J. P., once even appearing at a Soundgarden concert. (Chris Wedes collection.)

The irrepressible Bob Newman became Wedes's principal sidekick in 1960. Newman's roles included Ketchikan the Animal Man, the Swami of Pastrami, villainous Boris S. Wart, klutzy handyman Leroy Frump, and gravelly voiced biker Miss Smith. But he's best remembered as Gertrude, the City Dump telephone operator and J. P.'s off-and-on "love" interest. (Author's collection.)

Joe Towey (left) directed the Patches show and played occasional roles on it. His best-known character, "The Count," appeared sometimes with Patches but could mostly be seen on his own show, the midnight movie anthology *Nightmare Theater*. (Chris Wedes collection.)

Debuting in 1958, *The Stan Boreson Show* (alternately titled *KING's Klubhouse*) entertained young and old with Boreson's amiable personality and goofy song parodies, often delivered in a mock-Swedish accent. Boreson and his stoic basset hound No-Mo (short for No-Mo-Shun, a pun on the Slo-Mo-Shun hydroplanes) made innumerable public appearances (such as this at the Woodland Park Zoo). Boreson's chief human sidekick, Doug Setterberg (seen at left as "Space-Nik"), had brought his "Uncle Torvald" character from a KOMO Radio show. Setterberg's larynx was removed due to cancer in the mid-1960s; he returned to Boreson's show, using his electronic voice box to play a character named "Foghorn Peterson." Setterberg died shortly after the show's 1967 cancellation. Boreson (whom Garrison Keillor has praised as one of the last great Scandinavian-dialect humorists) still tours and records today. (Above, Deran Ludd collection; below, Seattle Municipal Archives.)

Also on KING-TV, *Wunda Wunda* (Ruth Prins) delivered gentle stories and songs from 1953 to 1972. In one recurring segment, she'd sing "The Wilting Willie Song" to a puppet flowerpot and invite kids to guess whether the flower would stay slumped over the pot's rim or soar to become "Stand-Up Willie." (Deran Ludd collection.)

Sheriff Tex (Jim Lewis) was the third leg of KING's kids' lineup in the 1950s. Broadcast historian David Richardson has called Lewis "a totally uninhibited Southerner" who "used to sing a little, do rope tricks, show live animals. Not even the crew knew what he would do next." (MOHAI, No. 1983.10.18202.1.)

Tacoma station KTNT's kid-friendly entry was *Brakeman Bill*. From 1955 to 1975, Bill McLain introduced cartoons and sitcom reruns in a vintage railroad-crew uniform. The show soon abandoned this early model railroad set for a painted train-yard backdrop and gave McLain a comic foil in Warren Reed's puppet Crazy Donkey. (Tacoma Public Library, Richards Studio Collection, D94438-1.)

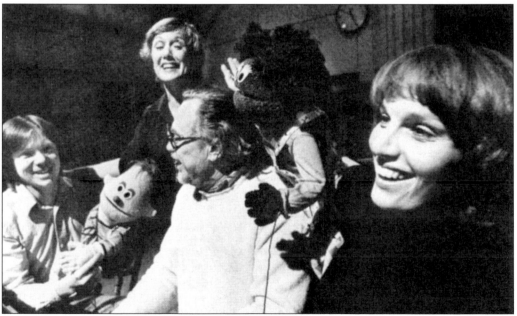

Marni Nixon had worked as the singing voice for such movie stars as Audrey Hepburn, Deborah Kerr, and Natalie Wood when she was picked to host KOMO's weekly kids' show *Boomerang*. It won 19 local and national awards during its 1975–1979 run. Seated in front of Nixon are puppeteer Lee Olson, musical director Stan Keen, and puppeteer Kathy Tolan. (From *View of Puget Sound*, Pacific Publishing.)

Don McCune (1918–1993) took on a nautical theme as KOMO's weekday kids' host *Captain Puget* from 1957 to 1966. He sang sea chanteys and songs about the Northwest between cartoons. Under his own name, McCune hosted KOMO's weekly travelogue show *Exploration Northwest* from 1960 to 1981. (Don McCune Library.)

McCune's frequent guest on *Captain Puget* was Ivar Haglund (1905–1985). Haglund was a popular local singer-raconteur when, in 1938, he opened an aquarium and fish-and-chips stand on the Seattle waterfront. That became Ivar's Acres of Clams, the first of a string of successful restaurants. In 1976, Haglund bought Seattle's first high-rise building, the 1914-built Smith Tower. (UW Special Collections, No. UW 18556.)

KING-TV, seeking visual spice for its early "talking head" newscasts, hired cartoonist Bob Hale to draw and narrate a "Daily Weather Picture." Hale's jovial air persona complemented his saucy drawing style (already famous from work for the Seattle Rainiers, Ivar's and Dag's restaurants, and many other clients). A Hale-drawn menu board still stands at the Pike Place Market's Athenian Inn. (Seattle Public Library.)

Hale's understudy and eventual successor at KING was Bob Cram, another busy commercial artist. Cram's on-air duties expanded into a weekly skiing show and, later, into commercials for QFC supermarkets (he'd also designed the chain's "Q-Head" mascot). Cram's book illustrations for historian and Underground Tour promoter Bill Speidel sometimes went beyond his wholesome TV work to caricature pioneer madams and lowlife figures. (Sunny Speidel collection.)

Among the first of Seattle's many colorful sportscasters was Leo Lassen, whose rasping monotone brought the Rainiers to radio audiences for nearly two decades. His catch phrases included, "If you've never been hit by a foul tip, you don't know what you're missing." Lassen had grown up directly south of the Sicks' Seattle Stadium site on Rainier Avenue; his family house is now Columbia Funeral Home. (MOHAI, No. SHS17300.)

Of all who enjoyed the Seattle Seahawks' 2005–2006 Super Bowl season, perhaps none would have loved it more than the NFL team's original 1976 radio announcers (clockwise from top): Pete Gross (1937–1992), Don Heinrich (1930–1992), and Wayne Cody (1937–2002). Gross was inducted into the Seahawks' "Ring of Honor" three days before he died of cancer. (From *View Northwest*, Pacific Publishing.)

A love note from Hardwick, Tam Henry, Jim French,
Jack Allen, Jack Morton, Peter B., and Robert O. Smith.

KVI 570 Radio

*Back row, left to right.

Before KVI became Seattle's first all-conservative talk station, it had a full-service entertainment format centered around strong air personalities. The leader of this pack was the mercurial and unpredictable Robert E. Lee Hardwick, who was DJ from 1959 to 1980—when he wasn't climbing mountains, driving race cars, or Jet Skiing from Alaska to Seattle. (From *View Northwest*, Pacific Publishing.)

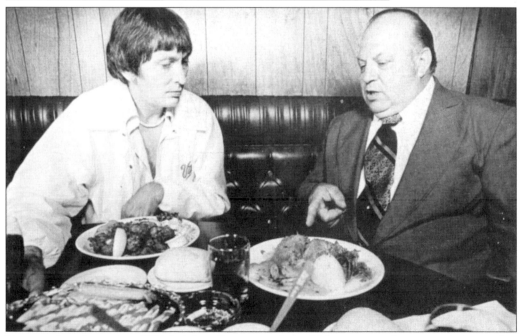

Compared to the antics of Hardwick and company, Larry Nelson ran a calm, reassuring morning show on KOMO-AM. His easy camaraderie with listeners made commuting at least slightly less stressful from 1967 to 1996. He's seen here with Vito Santoro, founder of Vito's Restaurant in the first Hill neighborhood. (From *View of Puget Sound*, Pacific Publishing.)

Pat O'Day (a stage name derived from the radio-industry term "daypart") was Seattle's first big rock DJ. His KJR afternoon shifts commanded up to 37 percent of the local audience. O'Day's concerts helped "break" such local stars as the Sonics and Merrilee Rush. O'Day later owned his own stations, wrote two volumes of memoirs, and still cohosts the annual hydroplane races for KIRO-TV. (MOHAI, *Post-Intelligencer* collection, No. 1986.5.37681.1.)

Charlie Brown (pictured here in 2005) was part of KJR's DJ crew from 1974 to 1980. He then teamed up with ex-Hardwick sidekick Ty Flint for 15 years on KUBE-FM, making it Seattle's leading pop-music station. He now sells software to help people create their own Internet radio shows. (Author's collection.)

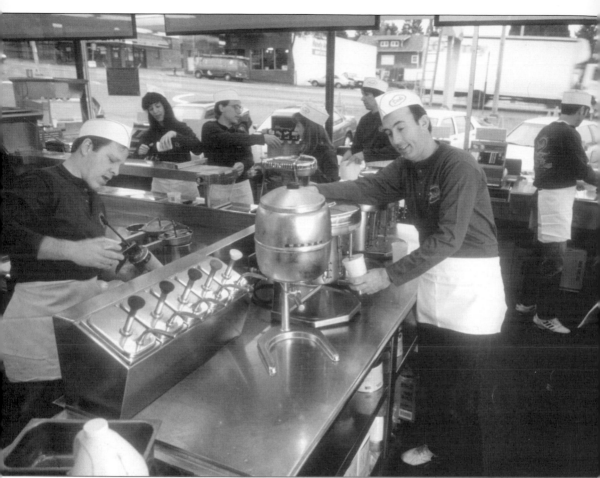

From 1984 to 1999, KING-TV's weekly sketch comedy *Almost Live!* chronicled and satirized the changing local scene. Among the trends they spoofed were the infestation of upscale chic upon a once-funky Seattle, Frederick and Nelson's slow demise, the rise and fall of grunge rock, and "the last street corner without a Starbucks." Along the way, cast member Bill Nye spun off his "Science Guy" character into a national children's show. In 1993, the *Almost Live!* writer-performers posed in this promotional shot for Dick's Drive-Ins. The five-outlet burger chain, founded in the Wallingford neighborhood in 1954, remains locally owned and operated to this day; *Almost Live!* lives on in reruns. Pictured here, from left to right, are Bill Stainton, Tracey Conway, Steve Wilson, Nancy Guppy, Bob Nelson, host John Keister, and Ed Wyatt. Pat Cashman was not pictured. (Dick's Drive-In Restaurants.)

AFTERWORD

Dick's Drive-Ins are still here. So are many other vestiges of the older, friendlier, happier Seattle.

You can still shop at the Pike Place Market, Uwajimaya, the University and Elliott Bay bookstores, Deluxe Junk, Archie McPhee's, Scarecrow Video, the Husky Deli in West Seattle, Eddie Bauer, the Goodwill and Salvation Army main stores, and the glorious 1925-vintage Sears on First Avenue South.

You can still eat at Ivar's Acres of Clams and Salmon House, the Baranof in Greenwood, Hattie's Hat in Ballard, Mama's Mexican Kitchen, Bimbo's Bitchin Burrito Kitchen, Bill's Off Broadway Pizza, Pizzeria Pagliacci, Spud Fish and Chips, the Five Point and Mecca cafes, Red Mill Burgers, 13 Coins, Ray's Boathouse, the Totem House, Andy's Diner, the Wedgwood Broiler, and many independent coffee houses, teriyaki stands, and taco wagons.

You can still drink and/or dance (but not smoke) at the Crocodile, the Lava Lounge, the Two Bells, the Streamline, the Virginia Inn, the Canterbury, re-Bar, Neighbours, the Wildrose, Linda's, the Rendezvous, Ozzie's, the Deluxe, the New Orleans, and the Blue Moon.

You can still view the preserved Pioneer Square buildings, the Cobb Building, the Olympic Hotel, the Hostess bakery, and the Bardahl and City Light neon signs.

You can still enjoy the annual hydroplane races, professional and college team sports, horse racing at Emerald Downs, and curling at the Granite Curling Club.

You can still see a live show at the Paramount, Moore, and Fifth Avenue theaters. You can still see a movie at the Egyptian, Cinerama, Seven Gables, Guild 45th, Admiral, Varsity, Grand Illusion, and Harvard Exit cinemas.

You can still ride to the top of the Space Needle, see an IMAX film at the Pacific Science Center, and watch a square dance at the Center House.

So go out and do some of these things today.